WORLD FILM LOCATIONS ISTANBUL

Edited by Özlem Köksal

First Published in the UK in 2011 by Intellect Books, The Mill, Parnall Road, Fishponds, Bristol, BS16 3JG, UK

First Published in the USA in 2011 by Intellect Books, The University of Chicago Press, 1427 E. 60th Street, Chicago, IL 60637, USA

Copyright ©2011 Intellect Ltd

Cover photo: Studio Babelsberg / Rose Line Productions / The Kobal Collection

Copy Editor: Emma Rhys

Intern Support: Joseph Smith

A Catalogue record for this book is available from the British Library

World Film Locations Series
ISSN: 2045-9009
eISSN: 2045-9017

World Film Locations Istanbul
ISBN: 978-1-84150-567-1
eISBN: 978-1-84150-594-7

Printed and bound by Bell & Bain Limited, Glasgow

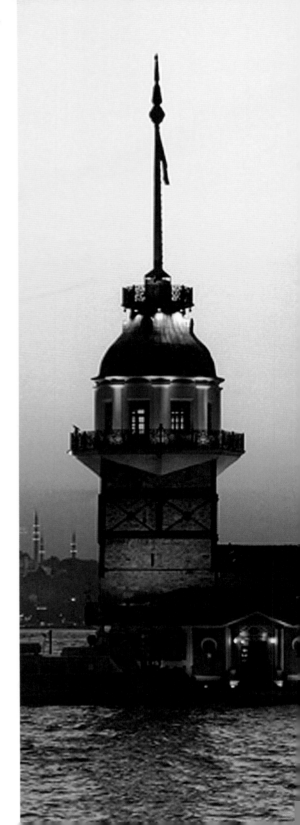

WORLD FILM LOCATIONS ISTANBUL

EDITOR
Özlem Köksal

SERIES EDITOR & DESIGN
Gabriel Solomons

CONTRIBUTORS
Cihat Arınç
Umut Tümay Arslan
Eylem Atakav
Senem Aytaç
Canan Balan
Melis Behlil
Feride Çiçekoğlu
Övgü Gökçe
Özlem Güçlü
Mustafa Gündoğdu
Ahmet Gürata
Zehra Derya Koç
Özge Özyılmaz
Yeşim Burul Seven
Levent Sosyal
Asuman Suner
Aslı Tunç
İpek Türeli
Fırat Yücel

LOCATION PHOTOGRAPHY
Zehra Derya Koç
(unless otherwise credited)

LOCATION MAPS
Joel Keightley

PUBLISHED BY
Intellect
The Mill, Parnall Road,
Fishponds, Bristol, BS16 3JG, UK
T: +44 (0) 117 9589910
F: +44 (0) 117 9589911
E: info@intellectbooks.com

Bookends: Haliç (Zehra Derya Koç)
This page: The Maiden Tower (Zehra Derya Koç)
Overleaf: The *Edge Of Heaven* (Kobal)

CONTENTS

ACKNOWLEDGEMENTS

I would like to thank the contributors, without whom this volume could not have possibly existed. I am also grateful to Alican Sekmeç for helping us source some of the images, and to Prof. Deniz Bayrakdar who read the "Istanbul: City of the Imagination" article and provided me with valuable comments, which I shall remember in the future too. Finally, I am indebted to my family and my friends for their help and support.

ÖZLEM KÖKSAL

INTRODUCTION

World Film Locations Istanbul

THE RELATION between film and the city is as intricate as our relation to each one of them. With its ability to not only represent space but also to misrepresent it; and, to fabricate novel spaces out of the existing ones, film has been the medium to imagine cities. Therefore, the city is often the un-credited actor in many films. Our understanding of most cities are formed through their representation on the big screen, interwoven with questions such as, how much of this representation corresponds to reality? And how much of that reality is shaped by the representations of it? Istanbul, in this story, indeed, does not differ from some of the more widely represented cities such as Los Angeles or New York; it is however much less explored on screen.

As part of a series that seeks to focus on this intricate relation through images as well as texts, this volume includes 38 insightful short reviews on particular scenes from individual films, and seven longer articles illustrating a variety of other topics in relation to Istanbul's representation in cinema, written by scholars and writers whose relationship to the city is as intimate as their relationship to the films themselves. The films included here vary from the 1960s James Bond film *From Russia with Love* (Terence Young, 1963) to German-Turkish director Fatih Akın's critically acclaimed *Gegen Die Wand/Head On* (2004), from Metin Erksan's cult film *Sevmek Zamanı/ Time to Love* (1965) to Nuri Bilge Ceylan's *Üç Maymun/Three Monkeys* (2008), taking you on a journey from Golden Horn to Üsküdar. However, it goes without saying that neither the list of films included in this volume nor the list of locations is a complete list. We can only hope to have covered some of the most important films while trying to pay a balanced attention to various different locations in the city.

As some of the reviews illustrate, the city has gone though a massive transformation. It is one of the considerations of this volume to create at least a sense of the extent of the change that has taken place in Istanbul over the last few decades. Some of these changes are visible in the location photographs included and some are detectable in the texts themselves.

As a final note, it is worth pointing out that, as with all the other books in the *World Film Locations* series, this volume is not designed as a tourist guide. It aims to bring texts and images together not in order to simply provide a panoramic view of the city (of which there is a glimpse to be caught with location maps) but to invite the reader to take a walk in the city. As Michel de Certeau once said, 'there is a rhetoric of walking' and it is only through walking in the city that you discover what is not available on the map. It is our hope that each review and article will together serve as utterances towards a particular walk within the city, one that is informed by the films that have used Istanbul so evocatively. The volume invites the reader on a journey through moving images in this historical, rapidly growing and, to me, one of the most beautiful and moving cities in the world. ✦

Özlem Köksal, Editor

ISTANBUL

City of the Imagination

Text by
ÖZLEM
KÖKSAL

ISTANBUL, with its long history and its surrounding beauty, is not only the city where film-makers have been, and still are, attracted to but is also the place that hosted the first ever film-screenings in the Ottoman Empire, and still forms the heart of the entertainment industry in the country. The most recognizable (and itself a cliché) image of Istanbul, created mainly for the western audiences, has to be the image of a sunset from behind a mosque, preferably with Bosphorus in the frame, an image that has been (over) used in cinema too. However, and unlike this single over-disseminated image wants to assume, the city is imagined in a variety of different ways by different film-makers, sometimes reproducing the familiar images, i.e. Sultanahmet, Haliç/Golden Horn and Beyoğlu/Pera, and sometimes creating a city that is not recognizable even for its inhabitants as Zeki Demirkubuz, Reha Erdem, Nuri Bilge Ceylan, among others, do.

As the city changed throughout the decades so did its cinematic representation. The 1950s and 1960s were the years that

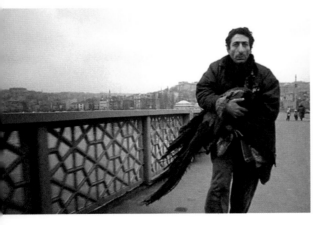

Istanbul received many immigrants from all over the country. In relation to the image of Istanbul in 1950s and 1960s films, Feride Çiçekoğlu, in this volume, points out that the arrival to the station from the provinces was itself a cinematic event with Haydarpasa Train Station's doors opening up to the blue waters of the Bosphorus. Istanbul, in these films, is represented as dazzlingly beautiful but equally perilous. These films imagined Haydarpasa as the entry point to the city, as a threshold between the East and the West, neither and both at the same time. Interestingly enough, it was also during the 1950s and 1960s that Istanbul was imagined by the West in a number of films as a city with curious qualities, the perfect setting for chasing the unknown(s).

However, the preferred location of entry to the city for western film-makers has been, and still is, the Galata Bridge as the audience often introduced to the city with an aerial shot of this bridge. Tom Tykwer's *The International* (2009) for instance does exactly that with a spectacular shot of the bridge to signify the characters' arrival to Istanbul. Although the bridge often appears in films made in Turkey, it is in the hands of western film-makers that it becomes the entry point to the city.

In recent years the image of Istanbul has been going through a significant transformation, at least from within. As Çağlar Keyder notes, during the 1980s, Istanbul was already becoming a global city 'designed for cultural consumption'. With the rapid economic changes taking place and the flow of people to the city, Istanbul became a 'divided city' rather than a 'dual city': while one part was participating in the global financial flow, the other part lived in the

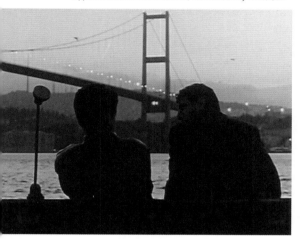

the means to make it their own. The city on screen, stripped of easily recognisable reference points, comes to represent the emotional as well as physical displacement of these characters, a place not only beyond comprehension but also lacking any memory for the newcomers. Hence Istanbul in these films does not correspond to the image of the city in circulation for touristic and other purposes. Perhaps one of the best-known cinematic representations of this division was Ceylan's *Uzak/Distant* (2002), where the division initially starts between the characters and then extends to their access to, and relationship with, the city.

Similarly, representation of some of the landmark locations in the city have changed in recent years: Istanbul, still an important location for film-makers, started to show its 'other-side' in films, where the city is represented as a giant prison for some of its inhabitants. When recognizable images are used they are contrasted with unknown, unheard stories of immigrants, displaced communities and the city's under-classes.

One of the landmarks of the city is the Bosphorus, which is always imagined as a separator (Europe vs Asia) rather than part of the unity. With considerable traffic taking place over its waters, the ferries carrying passengers between the two sides occupy an important place in the city's life hence in films. *Murder on the Orient Express* (Sidney Lumet, 1974), for instance, opens with an image of a ferry departing from the old Salacak ferry-port. This is a repeated scene in many films: the passenger ferries not only dominate the visual realm when it comes to the cinematic representation of the city, but they are also the dominant element of the soundtrack with their distinctive whistles.

Represented predominantly with its winding streets, decaying mansions, the minarets punctuating its skyline, the vast blueness that the Bosphorus inserts into the landscape, and the distinctive sounds of ferries, call for prayers, street vendors and seagulls, Istanbul is a city often imagined to be embodying a heartbreaking separation, not only temporal (the Ottoman Past and the Republican present) and spatial (the East and the West) but also spiritual. ✢

peripheries and remained by and large outside the global flow (Çağlar Keyder 1999: 15–17). This division also finds its way to the stories told in the recent years.

Writing on *Tabutta Rövaşata/Somersault in a Coffin* (Derviş Zaim, 1996) Asuman Suner points out that the image of Istanbul in the film is twofold: the first is Istanbul as experienced by the main character, who is a homeless man, and the second is Istanbul as a rising global city. This second Istanbul is largely inaccessible for the main character, creating, in Suner's terms, a 'confinement to open space' (Asuman Suner 2010: 142–7). In other words, the city, in the film, is 'divided' rather than 'dual', to reiterate Keyder's formulation. This condition is also repeated in many films mentioned here. In *Eşkıya/The Bandit* (Yavuz Turgul, 1997), *Anlat Istanbul/ Istanbul Tales* (Ümit Ünal et al. 2005), *Hayat Var/My Only Sunshine* (Reha Erdem, 2008) and *Journey to the Sun* (Yeşim Ustaoğlu, 1999), among many others, the characters' relation to Istanbul can be read as 'confinement to open space' not only because 'home' is somewhere else but also because this new place (the big city) denies them

In recent years the image of Istanbul has been going through a significant transformation, at least from within.

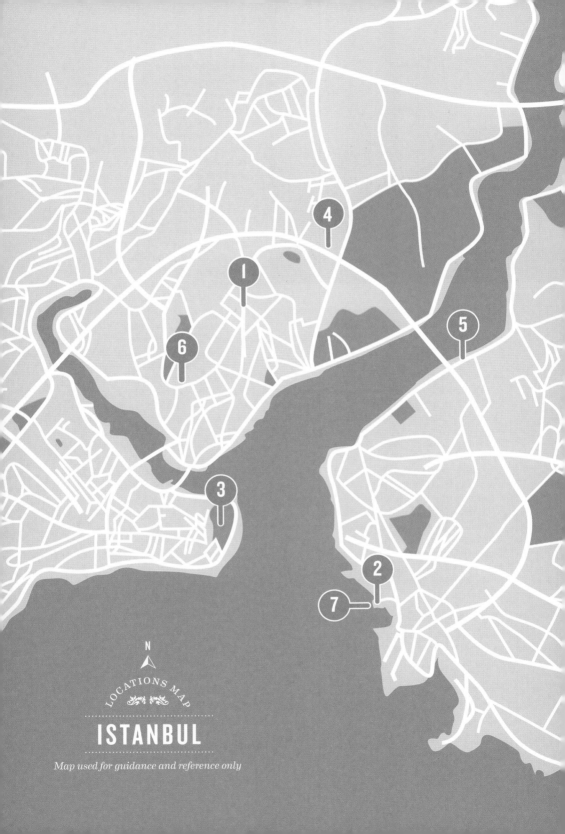

N

LOCATIONS MAP

ISTANBUL

Map used for guidance and reference only

ISTANBUL LOCATIONS

SCENES 1-7

FROM RUSSIA WITH LOVE (1963)

LOCATION

The Bulgarian Exarchate on Halaskargazi Street, Şişli.

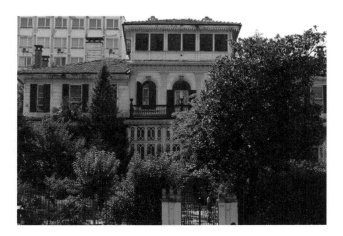

ONE OF the seminal Bond films, *From Russia with Love* is set partially in Istanbul, where James Bond (Sean Connery) assists the beautiful Soviet consulate clerk Tatiana Romanova (Daniela Bianchi) to defect. In a rather geographically creative scene, Bond and Ali Kerim Bey (Pedro Armendariz), head of the British intelligence service in Istanbul, descend through a dark and dank stairway from the Grand Bazaar into a Byzantine cistern dating back sixteen centuries. After a quick ride on a rowing boat, they find themselves underneath the Soviet Consulate, where Ali Kerim Bey goes twice a day to spy on the Russians. That there are nearly four miles and a significant body of water between the cistern and the consulate building in reality does not discourage our hero. The building standing in for the Consulate belongs to the Bulgarian Exarchate, founded in 1870 as a church independent of the Greek Patriarchy. The Exarchate today remains a haven for the locals as the only garden on Halaskargazi Street, in the heart of the once trendy, now more modest, but always lively Şişli district. The garden encompasseses not only the mansion seen in the film, but also a church, a hall and a small sports field, and functions as a centre for the miniscule Bulgarian community in Istanbul. Whatever the practical reasons may have been for using this location, the fact that a Bulgarian compound was chosen, particularly the one which once declared its – albeit ecclesiastical – independence, carries significant symbolic weight in a film that was shot during the hottest years of the Cold War. ↝ *Melis Behlil*

(Photos ©Zehra Derya Koç)

Directed by Terence Young
Scene description: Bond and Ali Kerim Bey travel through cisterns
Scene duration: 0:32:03 – 0:38:40

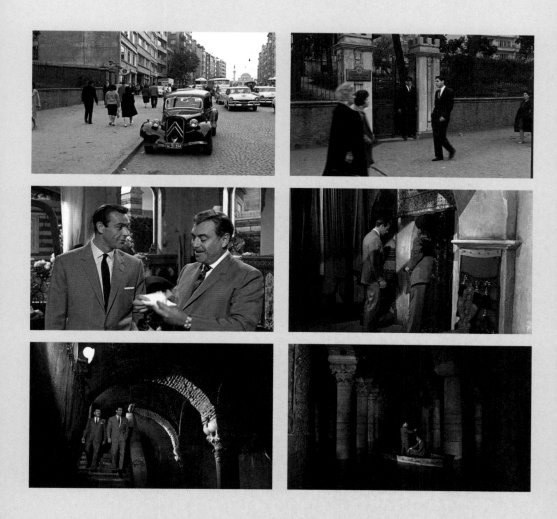

BIRDS OF EXILE/GURBET KUŞLARI (1964)

Front steps of the Haydarpaşa Railway Station

HALIT REFIĞ'S *Birds of Exile* tells the story of the Bakırcıoğlu family, who have come to Istanbul from a small town in the south-east of the country, set out to conquer the big city. The opening scene takes place at Haydarpaşa Train Station, the main station for the Asian side of the Bosphorus as well as the headquarters for Turkish Railways. After a brief introduction to family members as they get off the train, the scene continues on the steps outside the main terminal building, where the camera cuts to a point-of-view shot as the protagonists face the Istanbul skyline for the first time. The camera generously pans the entire breadth of the old city vista, establishing a pattern for all future cinematic immigrants and visitors, setting Haydarpaşa as the ultimate point of entry to the city. In fact, in a commercial for Chanel No. 5 directed by Jean-Pierre Jeunet, Audrey Tatou exits the Orient Express, and descends the very same steps as in the *Birds of Exile*, even though that is a geographical impossibility. As the western terminus for the Ankara-Istanbul line and formerly for the Baghdad-Istanbul Railway, the station is not only the last frontier in Asia for the railways traversing Anatolia, but also a symbol for the beginning of Europe. Built in the first decade of the twentieth century by German architects, the majestic neo-classical building is also clearly visible from all the waterways. Sadly, the top floors of the building were severely damaged by a fire in November 2010, but the station continues to fulfill its duties against all odds. **⬤Melis Behlil**

(Photos ©Zehra Derya Koç)

Directed by Halit Refiğ
Scene description: Bakırcıoğlu family arrives in Istanbul
Timecode for scene: 0:02:48 – 0:03:25

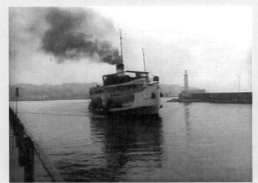

TOPKAPI (1964)

Topkapi Palace

AS IN MOST heist movies, the urban geography of the city plays a key role
as the setting for the action in *Topkapi*. Adapted from Eric Ambler's novel
Light of the Day, the film brings humour to the genre that was pioneered
by the very same Jules Dassin with *Rififi* (1955). *Topkapi* is narrated by
Elizabeth Lipp, a glamorous 45-year-old Melina Mercouri. Her object of
desire is a jewelled dagger on display at the impenetrable Topkapi Palace.
In order to steal the dagger, she contacts her ex-lover Walter Harper
(Maximilian Schell), a master criminal, and together they recruit an
eccentric group of amateurs to assist in the heist. Topkapi Palace, located
at the heart of the old city of Istanbul, is featured twice in the film: once
during the climatic burglary scene and once at the very beginning, as
the narrator Lipp introduces viewers to the Topkapi Palace Museum.
Speaking directly into the camera, she discusses various treasures as if she
were a tourist guide. Soon she pauses in front of a shinning dagger. She
is almost obsessed with this 'dazzling, flawless' object, which she believes
is incomparable with anything else in the palace. The Oriental tunes of
Manos Hadjidakis accompany this visual tour. Cinematographer Henri
Alekan creatively employed blue lenses in the garden of the palace and
a red one inside the treasury to highlight the atmosphere of the location.
Topkapi was Jules Dassin's first colour picture, and together with Alekan
he sought to best express the glamour and extravagance of both the palace
and the city. ➻*Ahmet Gürata*

(Photo ©Umut Türem)

Directed by Jules Dassin
Scene description: Elizabeth Lipp (Melinda Mercouri) introduces the Topkapi Palace Museum
Timecode for scene: 0:02:38 – 0:05:37

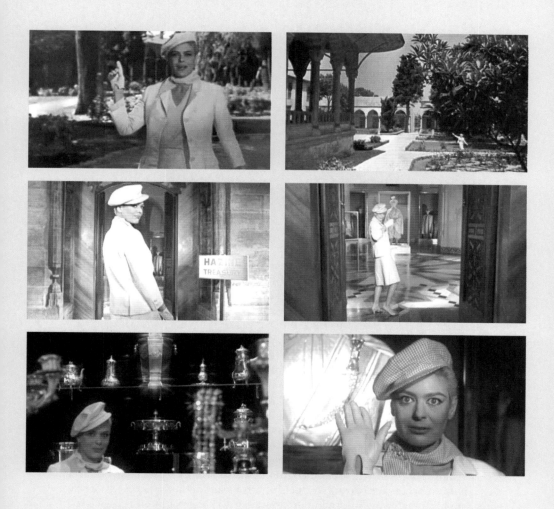

TIME TO LOVE/SEVMEK ZAMANI (1965)

LOCATION *Belgrade Forest*

METİN ERKSAN'S cult film *Time to Love* tells the story of Halil (Müşfik Kenter) who falls in love with an image, with a photograph of a young woman Meral (Sema Özcan), after encountering the image hanging on a wall in a house whose walls he was hired to paint. Having discovered this mysterious man and his feelings for her (photograph), Meral also finds herself in love with Halil. However, Halil is in love with a moment in time. He is afraid of the flow of life itself, afraid that reality will break his heart while, he argues, the photograph will never betray him. The film develops its narrative around their relation, telling an impossible love story with breathtaking images of Istanbul. In this particular scene towards the end, Meral is about to get married to another man but she runs away to be with Halil, who is to be found on a small rowing boat with Meral's picture and a manikin with a wedding dress, which he purchased after finding out about Meral's wedding. Meral, who is still wearing her wedding dress, gets on the boat and together they create one of the most poetic scenes in the film, involving no dialogue. The location for this scene was Belgrade Forest, where Erksan also imagined Halil's house to be. Located in the European side of the city, Belgrade Forest provides the idyllic beauty Erksan so carefully created for the dream-like world of Halil and his infatuation with a photograph. Analogous to Halil's obsession with a frozen image, the forest in the film appears as if time has been frozen to keep the beauty of the place intact. **⇢Özlem Köksal**

(Photo ©Özlem Köksal)

Directed by Metin Erksan
Scene description: Meral and Halil on a rowing boat
Timecode for scene: 1:14:56 – 1:22:49

Images ©1965 Troya Film

17

OH BEAUTIFUL ISTANBUL/
AH GÜZEL ISTANBUL (1966)

LOCATION *Beylerbeyi*

ONE OF THE MOST memorable films from the classical period of Turkish cinema, *Oh Beautiful Istanbul* starts with Haşmet's lengthy conversation addressed to the camera. Played by the great Turkish actor, Sadri Alışık, Haşmet gives an elaborate yet unpretentious speech about the Ottoman past of his family, the loss of their familly assets, and the details of his life as a broke, middle-aged bachelor. After leaving his favourite restaurant, he takes a walk down the road in one of those old Istanbul neighbourhoods with his long trenchcoat, a hat and an umbrella, that establish him as a well-respected gentleman, although less and less fitting to the modern times. As Haşmet arrives at Beylerbeyi pier, the camera follows his gaze and gets absorbed in the beautiful landscape of the Bosphorus. We see Haşmet peering at this landscape with an inner voice that recollects the long history of the city, aware that he is mimicking the past gazes of his forefathers and yet sighing with a pinch of nostalgia for 'what is lost'. Atıf Yılmaz is aware of the illusion this sort of nostalgia might bring and breaks away from it by rousing Haşmet with a sudden sound of a sliding pathway of the ferry. As Haşmet ridicules himself for getting lost in his thoughts and merges with the crowd getting on the ferry, his incongruity with the changing cultural scape of Istanbul sets the tone of the film. The scene was shot in Beylerbeyi, an old Istanbul neighbourhood where the famous Beylerbeyi Palace is located. *Oh Beautiful Istanbul* sketches the city (and everything it represents) as a composition that surfaces in between the East and the West and the old and the new, oppositions that have been repeated but not much questioned in Turkish cinema ➡ ***Övgü Gökçe***

(Photos ©Zehra Derya Koç)

Directed by Atıf Yılmaz
Scene description: Haşmet walks in Beylerbeyi
Timecode for scene: 0:00:00 – 0:04:00

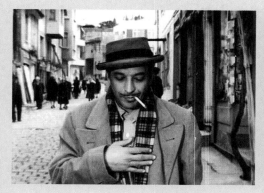 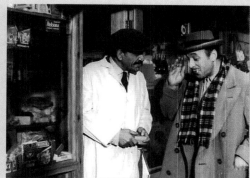

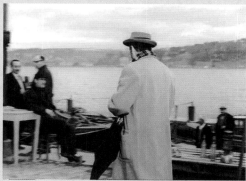 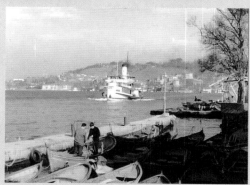

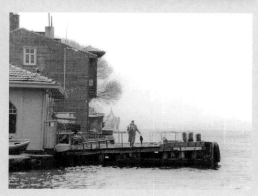

Images ©1966 Be-Ya Film

MY LICENSED BELOVED/VESIKALI YARIM (1968)

LOCATION *Çağlayan Saz, İmam Adnan Sokak, Beyoğlu*

ÖMER LÜTFİ AKAD'S *My Licensed Beloved* (taking its title from a licence given to sex workers) is, without a doubt, one of the most important films made in Turkey. The film tells a story of an impossible love, casting Istanbul as one of its characters. Director Akad assigns neighbourhoods and places to particular moods and characters in his portrayal of the city: Halil lives in a family oriented modest neighbourhood, Kocamustafapaşa, whereas Sabiha, who works as an escort in a nightclub (*pavyon*), lives in the more cosmopolitan Galata. In this particular scene Halil and his friends go to the nightclub where Sabiha works, where Halil, who is otherwise a devoted family man, sees Sabiha for the first time. At this moment of unexpected encounter, Sabiha seductively approaches Halil. As he lights her cigarette, smoke surrounds her face and his entire world comes to a halt: sounds and faces disappear momentarily and she becomes the only being visible to his eyes. This iconic scene is also mentioned in Orhan Pamuk's *Black Book*, as Pamuk recreated this, one of the most memorable scenes in the history of film-making in Turkey, with his lost-in-dreams character Galip. The venue used for nightclub scenes was a place called Çaglayan Saz in the Beyoğlu district. Located on a small street (İmam Adnan Sokak) off the İstiklal Street, Çaglayan Saz was used as a venue for similar nightclub scenes in a number of other films at the time. With the changing scenery in Istanbul Çaglayan Saz, as well as many other clubs similar to this one, disappeared from the city's nightlife. Today a cafe exists in its place. **⚭Özlem Köksal**

(Photos ©Zehra Derya Koç)

Directed by Ömer Lütfi Akad
Scene description: Halil and Sabiha meet for the first time
Timecode for scene: 0:09:55 – 0:11:15

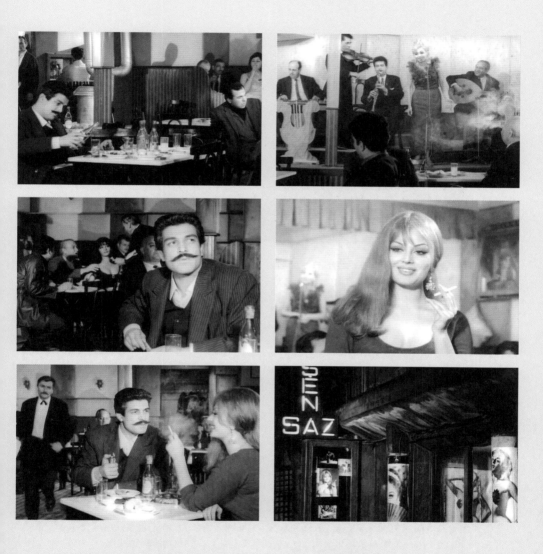

MURDER ON THE ORIENT EXPRESS (1974)

Salacak seaport, Üsküdar

ISTANBUL IS THE ONLY city in the world that is located on the brink of two continents, Europe and Asia. While the main part of the city, the European side, has long been a major filming location, the suburbs in Asia are often neglected both by tourists and by film-makers. Sidney Lumet's *Murder on the Orient Express*, set in the 1930s as in Agatha Christie's book of the same title, begins at a small seaport in Üsküdar, on the Asian shores of Istanbul, after a brief prologue featuring newspaper clippings and black-and-white footage of the kidnapping and murder of three year-old Daisy Armstrong in Long Island, New York. Üsküdar lies opposite the Golden Horn and its seaport connects the passengers of the Orient Express via the Bosphorus ferry line. In this introductory scene, we meet some of the key characters of the film, such as the famed detective Hercule Poirot (Albert Finney). Street vendors and a herd of sheep greet the passengers embarking from Üsküdar. Once the ferry leaves the Salacak seaport, which no longer exists, we see one of the most familiar sites of Istanbul: The Maiden's Tower (Kız Kulesi), and also clearly visible in the background are the Blue Mosque and St. Sophia Church. This spectacular sunset scene provides a poignant point of contrast for the rest of the film, which is claustrophobically set in a single location. At one point, the British soldier sitting next to detective Poirot asks whether they did the right thing by booking him a hotel on the European side rather than the Asian side. Poirot replies: 'I've no prejudice against either continent' – and neither does the film. ➻ *Ahmet Gürata*

(Photos ©Zehra Derya Koç)

Directed by Sidney Lumet
Scene description: *Bosphorus ferry departing from Salacak*
Timecode for scene: *0:05:15 – 0:09:16*

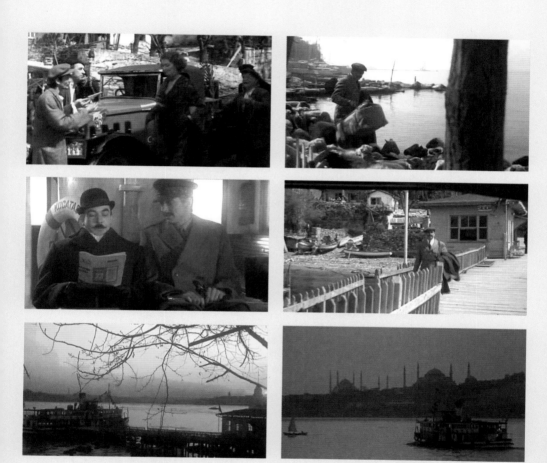

CITY OF INTRIGUES

Text by
AHMET
GÜRATA

Istanbul as an Exotic Attraction

ISTANBUL HAS BEEN a popular setting for international film-makers since the inception of cinema. In 1896, Alexander Promio, a cameraman working for the Lumière Brothers, visited the city and filmed two of the most spectacular places in Istanbul: the Bosphorus and the Golden Horn. *Panorama de la Corne d'Or* and *Panorama des rives du Bosphore* both consist of a single tracking shot filmed from a rowboat, documenting Istanbul's deep intimacy with the sea. These bodies of water are the quintessential starting point for almost every depiction of Istanbul. Particularly well-known is the Galata Bridge with its panoramic view over the Golden Horn, and most international cinematic tours of Istanbul start with a tracking or aerial shot over the bridge.

During the silent era, Istanbul was often represented as an exotic, foreign locale, holding to Orientalist tropes. In these films, western heroes rescue beautiful girls from the hands of mischievous sheikhs, as in Tod Browning's *The Virgin of Stamboul* (1920).

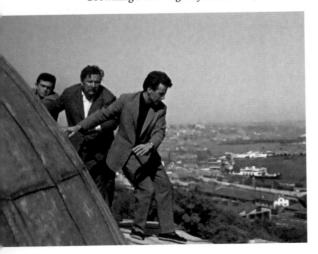

During and after World War II, Istanbul, as a city of espionage and political intrigues, became an ideal destination for film noir. *Journey into Fear* (Norman Foster, 1943), *Background to Danger* (Raoul Walsh, 1943), *The Mask of Dimitrios* (Jean Negulesco, 1944) and *5 Fingers* (Joseph L. Mankiewicz, 1952) all depict a city rife with mystery and intrigue. These films offer an atmospheric studio version of Istanbul with occasional stock footage, while hints of realism were added with signs written in Turkish, street sounds and rear projection.

Stories of geopolitical intrigue continued during the Cold War era with *From Russia with Love* (Terence Young, 1963). Sean Connery as James Bond discovers some of the most prominent sites of Istanbul in the film: the Blue Mosque, Dolmabahce Palace and the Bosphorus. The mysterious underground passage in the film is in fact the Basilica Cistern (*Yerebatan Saray*). Urban legends abound about the Basilica Cistern, which was originally used for water storage for the Byzantine Palace. As a space that connects the world above with a world below, it constituted an ideal setting for mystery and horror in a number of films. Jules Dassin's *Topkapi* (1964), apart from such historical sites, also depicted scenes of an Istanbul which was newly modernizing, including the Istanbul Hilton, a symbol of capitalism and modernity that was built in 1954.

A rather different depiction of Istanbul appears in Alain Robbe-Grillet's *L'immortelle* (1963). Shot entirely on location *L'immortelle* tries to capture the well-known postcard images of Istanbul. However, the film suggests that these tourist images are constructed through the fantasies of the main character N and us, the spectators. The mosques, secret gardens, and harems of this 'legendary

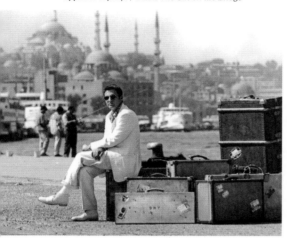

world' form a backdrop for N's erotic fantasies. Similarly, *Vampiros lesbos* (Jesus Franco, 1971) employs some of the conventions of European art cinema to create an atmosphere of erotic intrigue. In this film, directed by Jesus 'Jess' Franco, the Princes' Islands, off the coast of Istanbul, form the setting for an otherworldly venture into lust and ruses.

Sidney Lumet's *Murder on the Orient Express* (1974) recreates the atmosphere of 1930s Istanbul. Apart from picturesque images of Istanbul, hotel Pera Palas, where Agatha Christie used to stay, is also featured in the film. *Midnight Express* (Alan Parker, 1978), on the other hand, is mostly set in a prison, but Istanbul is briefly seen when the main character attempts to escape in a crowded market. The film was critiqued for its portrayal of Turkey and the Turkish people.

Istanbul has also been depicted as a refuge for the destitute and heart-broken characters of European cinema. In *Zombie ja Kummitusjuna/ Zombie and the Ghost Train* (Mika Kaurismaki, 1991), *Zombie* (Silu Seppala), who is adrift in depression, slips away to Istanbul. In this film, Istanbul is a ghost city full of melancholic

drinkers who gather at the bars under Galata Bridge. Galata Bridge also appears in *La fille sur le pont/The Girl on the Bridge* (Patrice Leconte, 1999), this time as the final destination. The knife-thrower Gabor (Daniel Auteuil) decides to end his life there, by throwing himself into the waters of the Golden Horn after he is separated from his lover.

Istanbul has also attracted many other figures of world cinema. In Jackie Chan's *Te wu mi cheng/The Accidental Spy* (Teddy Chan, 2001), the Grand Bazaar was yet again selected for the setting of a chase. Globally expanding Bollywood also visited Istanbul recently. *Mission Istaanbul: Daar Ke Aagey Jeet Hai!* (Apoorva Lakhia, 2008) features chase and action scenes in various districts of Istanbul, including the Grand Bazaar and its roof. With its maze-like structure, the fifteenth century Bazaar provides an ideal setting for action and adventure.

In recent years, Hollywood also returned to its city of intrigues with yet another James Bond movie, *The World is Not Enough* (Michael Apted, 1999), in which villain Elektra King plans to destroy Istanbul by detonating a nuclear submarine in the Bosphorus. The film includes a scene at the Maiden's Tower, located at the mouth of the Bosphorus and yet another typical postcard image of the city. Most recently, Tom Tykwer's *The International* (2009) includes Istanbul among many locales as part of a global intrigue. The Interpol detective Louis Salinger (Clive Owen), hoping to wrap up his investigation in Istanbul, ultimately fails after a series of tailings and chases in the Blue Mosque, Basilica Cistern and Grand Bazaar.

Despite the differences in their origin and genre, the similarities between these cinematic texts are striking. They often use the same landmarks, starting with the Galata Bridge and ending at the Grand Bazaar via the Blue Mosque. In fact, the clichés of how Istanbul is signified in cinema has not changed much since the early travelogues. As a cosmopolitan city, Istanbul provides a setting for a number of binary oppositions such as East-West, communist-capitalist, Asian-American, and exotic-modern. These ideological oppositions reinforce the conventions of cinema tinged by Orientalist tropes in most of the films set in Istanbul, whether old or new. ✢

As a cosmopolitan city, Istanbul provides a setting for a number of binary oppositions such as East-West, communist-capitalist, Asian-American, and exotic-modern.

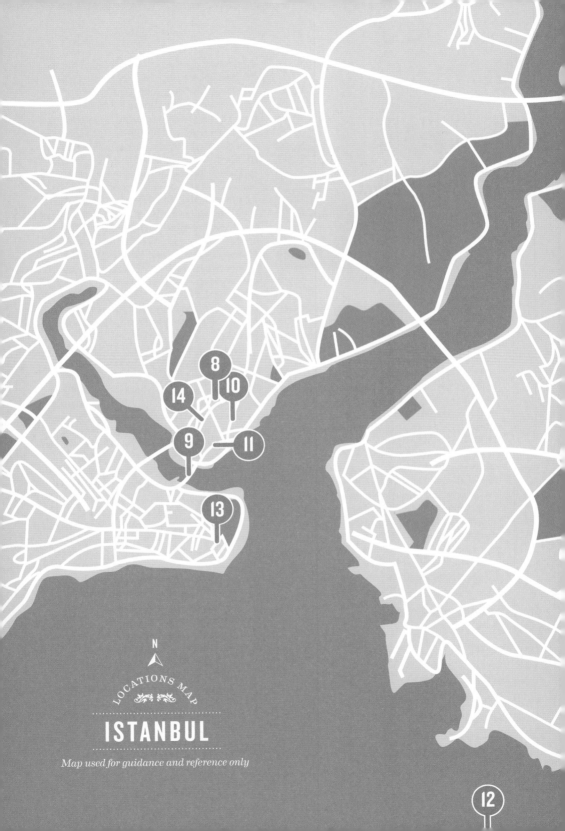

LOCATIONS MAP

ISTANBUL

ISTANBUL LOCATIONS

SCENES 8-14

FRIEND/ARKADAŞ (1974)

Çiçek Pasajı, Galatasaray, Istanbul

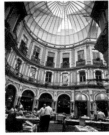

ARKADAŞ, meaning 'friend' but also 'comrade' in the parlance of the period, is an odd entry in Güney's oeuvre. Structured as a 'rich girl-poor boy in love' film, it is Güney's attempt to engage in class differences while staying true to one's commitments. It takes place in Bayramoğlu, a then up-and-coming resort town at the Asian end of Istanbul (Kumburgaz had the same attraction on the European end; both places had long lost their appeal). The scene in question, however, is not in Bayramoğlu but comes after a series of ethnographic shots of bourgeois decadence on the beach. In this scene, taking place in Çicek Pasaji (Flower Passage), Azem, played by Güney himself, meets his old college friend Cemil (Kerim Afşar) for the first time in the film. Again, as if writing an ethnography, Güney documents the folksy quality of life in this celebrated drinking hole: beer in tall glasses, fried mussels, kokoreç (grilled intestines), accordion player Madam Anahit, drinkers and passers-by. In the 1970s, Çiçek Pasajı was packed with students, intellectuals, and after-work crowds, as it was the-place-to-be for a conversation over beer. Built as 'Cite de Pera' in the 1870s, the likes of which are to be found in Milan and Paris, Çiçek Pasajı is no longer a living venue but a renovated place, adorned with hanging flower pots and framed pictures of its celebrities, including the late Madam Anahit. As the neighbouring fish market has retreated under the attack of gift shops selling cheap traditions, the passage lost its crowd to the nearby Nevizade Street. After leaving Çiçek Pasajı, Güney's camera lingers in yet another locale erased from Istanbul's cityscape, Sulukule, the lowbrow entertainment district, now marked for gentrification. *Arkadaş* reads like a dated ethnography of times and places gone by. **➻Levent Soysal**

(Photos ©Zehra Derya Koç)

Directed by Yılmaz Güney
Scene description: Azem and Cemil meet in Çiçek Pasajı
Timecode for scene: 0:04:20 – 0:08:01

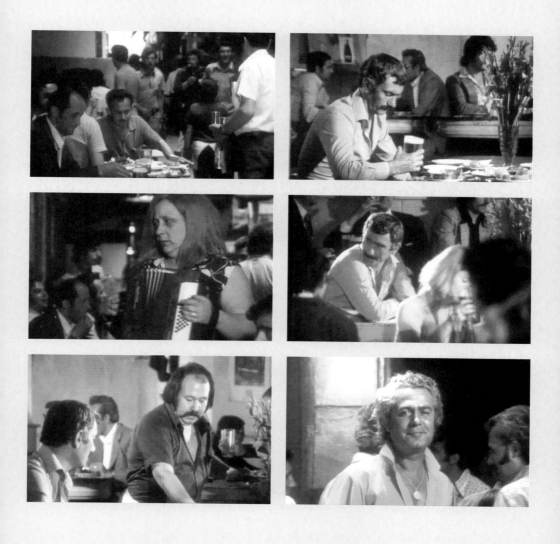

OH BEAUTIFUL ISTANBUL/
AH GÜZEL ISTANBUL (1981)

LOCATION *Old Galata Bridge, between Karaköy and Eminönü*

GALATA BRIDGE is the location of Cevahir's (Müjde Ar) suicide scene, who has lost hope of a happy ending to her love story with the truck driver Kamil (Kadir Inanır). The bridge over the Golden Horn was the link between the historical peninsula, the district of mosques, and Pera (the other side) where the non-Muslim population lived. Pera was seen as the 'sleazy underbelly' of the city during the late nineteenth century, a metaphor inherited by the literature and cinema of the past century. Ömer Kavur's film is the screen adaptation of Füruzan's story by the same title. The story continues the tradition of melodramatic love stories between a prostitute and a working-class man, who do their best to live together but are doomed to fail. These stories were typical of mid-twentieth century Istanbul, which was in the grip of fast modernization and urbanization. Kavur's film portrays the female protagonist not as the object of desire, but as a subject who embraces her sexuality, which may be considered as a fresh point of view for Turkish cinema at the time. Her suicide, however, continues the melodramatic tradition, that she cannot escape her tragic fate and dies. The bridge itself was moved to another location between Balat and Hasköy over the Golden Horn after the fire in 1992, which mostly destroyed it. A new bridge with the same name replaced it. The old Galata Bridge now hosts cultural activities such as performances and fashion shows. ➻*Feride Çiçekoğlu*

(Photos ©Özlem Köksal)

Directed by Ömer Kavur
Scene description: Cevahir attempts to kill herself
Timecode for scene: 1:29:36 – 1:30:58

 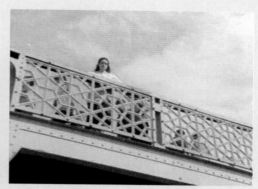

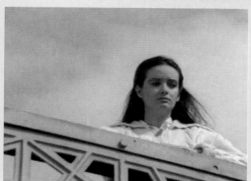

 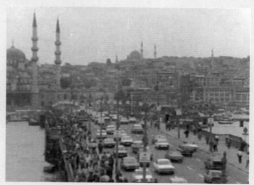

MY DREAMS MY BELOVED AND YOU/
HAYALLERIM ASKIM VE SEN (1987)

LOCATION *Tarlabaşı-Karaköy*

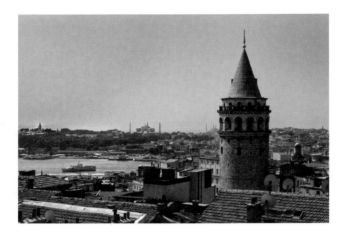

IN ATIF YILMAZ'S *My Dreams My Beloved and You,* there is an otherwise insignificant scene where the young protagonist Coşkun (Oğuz Tunç) is thinking about how Istanbul has changed his life. As the film develops it becomes clear that there is a connection between his destiny and that of the city. The film tells the story of Coşkun who wants to write a screenplay for his favourite Yeşilçam star Derya Altınay (Türkan Şoray). In telling Coşkun's story the film also tells the story of the uneven neo-liberal transformation the country went through in the 1980s, as well as the collapse of the glorious Yeşilçam (the Turkish equivalent of Hollywood albeit on a miniscule scale). Beyoğlu, for this reason, is an important locale in the film's narrative structure as it is the district where not only the famous Yesilçam street (where the film studios are located) is to be found but also the place where this rapid change was felt the most. The scene in question where Coşkun talks about his relationship to the city, testifies to the fact that the human soul cannot be thought separate from the soul of a place. As Coşkun writes, 'I believe that what made me go astray was not my emotions or my up-tight nature but the narrow and wide streets of this city, spreading further with their increate stairs, streets that are full of underground passages.' The camera takes us to Tarlabaşı where many of its non-Muslim population were displaced and where houses were demolished to gentrify the location in the 1980s. It is through this scene, in which we also see nearby districts Galata and Karaköy, that we understand that while Coşkun's screenplay is being transformed into a cheap erotic movie the city is also turning into something beyond recognition.
↪Fırat Yücel (text translation by Özlem Köksal)

(Photos ©Zehra Derya Koç)

Directed by Atıf Yılmaz
Scene description: Çoşkun thinks about how Istanbul changed his life
Timecode for scene: 0:43:33 – 0:45:13

Images ©1987 Odak Film

MUHSIN BEY (1987)

LOCATION *Serdar-ı Ekrem Sokak*

THE OPENING OF Yavuz Turgul's *Muhsin Bey* follows its title character (Şener Şen) through his morning routine from his decrepit apartment out to his car, which – apparently routinely – fails to start. Muhsin Bey is an old-fashioned Istanbul gentleman and a struggling music producer who is trying to survive the frantic cultural transformation of Turkey, which started in the mid-eighties. Outdoor scenes of the film were shot on location and Muhsin Bey's home in the old Doğan Apartment in the Galata neighbourhood is itself a symbol of the twentieth century's various urban transformations. The building, consisting of four six-story blocks with a courtyard overlooking the opening of the Bosphorus, was built in the last decade of the nineteenth century as a residence aimed largely at the non-Muslim population of the Beyoğlu district. From the 1950s onwards, when Armenian and Greek minorities started leaving Istanbul, and following the migration from rural areas into the city, the building was occupied largely by recent migrants from rural areas. *Muhsin Bey* demonstrated the run-down state of the once stately apartments – much like the old, and possibly once beautiful, Armenian landlady the protagonist bickers with on his way out. Paradoxically though, the critical and popular success of the film helped to reverse the building's fortunes. Flats in Doğan Apartment are now purchased or rented mostly by celebrities and expats. The building underwent a series of facelifts throughout the 1990s and could possibly be considered as the driving force in the gentrification process of the entire area. Muhsin Bey could no longer afford to live there. ◆**Melis Behlil**

(Photos ©Zehra Derya Koç)

Directed by Yavuz Turgul
Scene description: Opening sequence, Muhsin leaves his apartment
Timecode for scene: 0:01:50 – 0:03:43

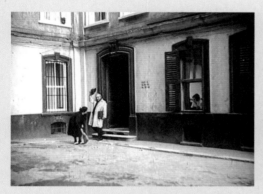 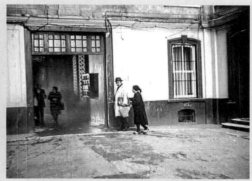

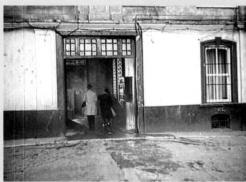 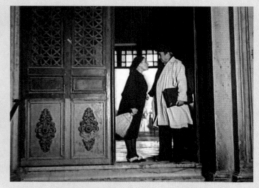

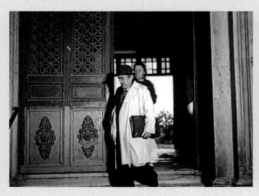 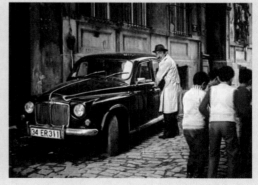

Images ©1987 Umut Film

A AY (1989)

REHA ERDEM'S FIRST FEATURE *A Ay* has a loose narrative that creates a dream-like story with a non-linear technique, rather than the commonly used linear narrative forwarded by events. The main character Yekta, a young girl in her early teens, lives with her aunt Nükhet (Nurinisa Yıldırım) in an old, decaying, and apparently incomplete, mansion in Istanbul. Her other aunt Neyyir (Gülsen Tuncer), an English teacher living in Burgazada (a small island off the cost of Istanbul and part of the group of islands known as Princes' Islands), comes to visit them every now and again and wants Yekta to live with her in Burgazada as she thinks the house is too depressing for a girl her age. In this scene Yekta and aunt Nükhet go to Burgazada to visit aunt Neyyir. As they alight from the ferry at the Burgazada ferry-port Neyyir's voice is heard: 'Lets go to the Splendid for tea!' What begins as a scene in Burgazada ferry-port, ends in Büyükada, another island (the biggest one among the Princes' Islands) where the Splendid Hotel is also located. Reha Erdem, famous for creating his own Istanbul and shifting locations as he pleases, has his characters going to the Splendid Hotel's cafe to have tea, imagining the hotel in Burgazada. His imagination of the city is reminiscent to that of a child's where places are remembered not by their geographical locations but by their distance to the heart and mind, by their locations on an emotional map. ⟿ *Özlem Köksal*

(Photos ©Menderes Naç)

Directed by Reha Erdem
Scene description: Arriving at Burgazada and having tea at the Splendid Hotel
Timecode for scene: 1:07:11 – 1:10:40

Images ©1989 Atlantik Film

DON'T LET THEM SHOOT THE KITE/
UÇURTMAYI VURMASINLAR (1989)

LOCATION *The old Sultanahmet Prison*

THE SCENE OF a five-year-old boy leaning against the imposing prison wall with hands in his pockets is definitely an iconic image in Turkish cinema. The cruelties and absurdities of the September 12 military coup are told through the eyes of a little boy (Barış) in *Don't Let Them Shoot the Kite*. The sharp contrast between vast empty spaces and Barış's tiny body gives the audience a feeling of loneliness. The shots of the steep staircase leading to the courtyard and Barış's posture as he sits at the edge of a bench next to the high prison wall skillfully reflect the boy's entrapment in this cold setting. Because of his mother's arrest, little Barış has no choice but to stay in a women's prison with his mother along with many other female inmates. The plot revolves around his heartwarming discovery of love, friendship and freedom. The screenplay of this cult political movie is an adaptation of Feride Çiçekoğlu's book based on her personal experiences. Although the story takes place in Ankara and the setting is believed to be Ankara Prison, it was actually shot at Sultanahmet Prison, a building with neo-classic style architecture built in 1918. It is located at the heart of Istanbul's historic peninsula including the Blue Mosque, Hagia Sophia and the Topkapı Palace. A number of Turkish literary figures and dissident intellectuals such as Nazım Hikmet, Kemal Tahir, Aziz Nesin, Rıfat Ilgaz, and Orhan Kemal served time in this prison until it was closed down in 1969. Famous novelist Graham Greene also mentions the Sultanahmet Prison in his 1932 thriller, *Stamboul Train*. As an indicator of the country's dramatic change in its social fabric, the prison has been renovated and was turned into a luxury Four Seasons Hotel in 1996. **•♦ Aslı Tunç**

(Photos ©Zehra Derya Koç)

Directed by Tunç Başaran

Scene description: The little boy in the prison courtyard
Timecode for scene: 0:03:35 – 0:04:45

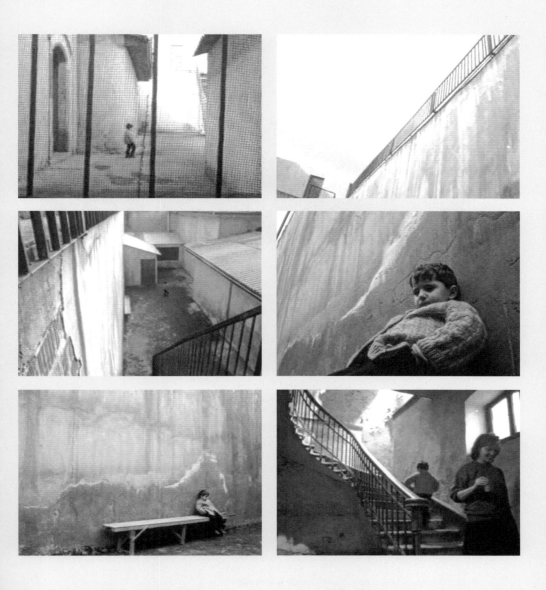

Images ©1989 Magnum Film

HIDDEN FACE/GİZLİ YÜZ (1991)

LOCATION *Hazzopulo Passage*

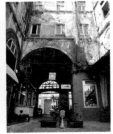

HAZZOPULO PASSAGE, an arcade which connects Istiklal and Meşrutiyet streets in the main shopping and entertainment district of Beyoğlu, appears briefly but spectacularly in Ömer Kavur's film *Hidden Face*. The passage dates from 1871 and is a t-shaped courtyard opening up to Panaya Isodyon Church. The names of the streets, Istiklal (Independence) and Meşrutiyet (constitutional monarchy), are loaded with historical connotations since the former points to the Republican and the latter to the Ottoman periods. The name of the passage was changed more than once, for example Danışman Geçidi (Danışman Passage) was used in the 1980s, a name coined by the military junta of 1980 in the hope of suppressing the Greek origin of the location, as the original Hazzopulo is a Greek word. Hazzopulo Passage was restored in 2002 with its original name, with an additional restaurant. The passage still houses the handmade hat shop of Madam Katia and has kept its original atmosphere thanks to the Podima stones used as floor finishing. These stones were collected from the shores of Marmara, from a small town then known as Podima, and characterize the open spaces of some of the important public buildings built in the late nineteenth century. It must have been mainly the floor finishing that made Ömer Kavur shoot this short scene in Hazzopulo Passage. In Orhan Pamuk's screenplay – the only screenplay he wrote before he became a world renowned novelist – this particular scene is just one sentence: 'The photographer passes from Beyoğlu streets'. Kavur has created an unforgettable cinematic image of the courtyard as the photographer quickly walks out, passes by a tree and disappears into the third exit of the passage. **→Feride Çiçekoğlu**

(Photos ©Zehra Derya Koç)

Directed by Ömer Kavur
Scene description: *The photographer wonders around Beyoğlu*
Timecode for scene: 0:08.44 – 0:08.56

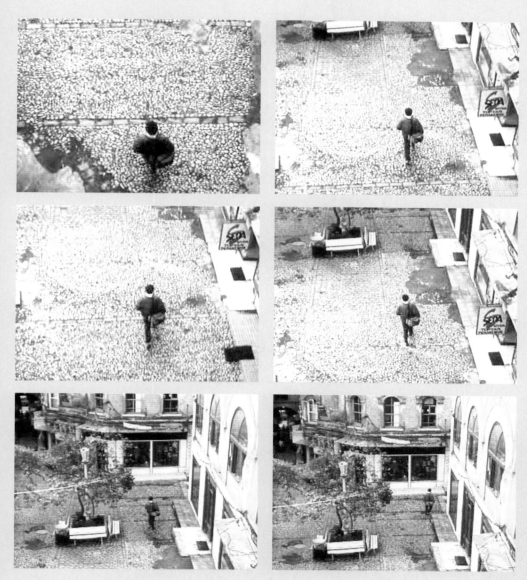

Images ©1991 Alfa Film

THRESHOLD OF THE CITY

Haydarpaşa Train Station

Text by
FERİDE
ÇİÇEKOĞLU

HAYDARPAŞA TRAIN STATION is the threshold of the city in black and white films of Turkish cinema. The newcomers arrive from the provincial towns of Anatolia in search of a better life in Istanbul and once they emerge from the magnificent door facing the sea, they find themselves at the top of the stairs leading to the ferry. The ferry will cross the Marmara Sea and take them from Asia to Europe, to the other side, which is full of promise. They have never seen the sea before, let alone boarded a ferry. They look at this vast body of water separating them from the historical city with its skyline of minarets, distant and huge, sprawling from one end to the other, in an attractive yet threatening composure. The newcomers look back, as if for a last chance of retreat, only to be faced by the huge façade of the station, towering over them with pride. The clock at the top looks uncanny as if time has a different pace in Istanbul and they hesitate. That moment of hesitation, full of awe and expectation, resolution and intimidation, is the cinematic image of the threshold of Istanbul.

When the Turkish Republic was founded in 1923, the official history promoted by the one party regime of the People's Republican Party introduced the new capital Ankara as the centre of nation building and negated the past, which was represented by Istanbul, the Ottoman capital. It took more than two decades for Istanbul to reclaim its historical pride and to restore its image. Towards the end of the 1940s, developing capitalism was dissolving the feudal relations, which had kept the rural population tied to villages. 1950 was marked not only by the elections, which ended the People's Republican Party's tenure, but also by a turning point in the fate of Istanbul. The city became a centre of attraction for the immigrants pouring out of Anatolia from then on, with the myth that its 'stone and soil was made of gold'.

It is no coincidence that the iconography of Haydarpaşa Train Station as the threshold of the city appears for the first time in the same year, with the film *Istanbul Geceleri/The Nights of Istanbul* (Mehmet Muhtar, 1950). The film tells the story of two men who come to Istanbul to enjoy the nightlife of the city, which they have never seen before. Their tragicomic adventures set the tone for the black and white films of the 1950s and 1960s, during which the population of Istanbul more than doubled. The protagonists of the

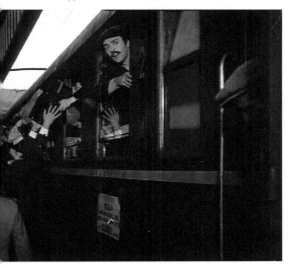

lowed to look at the women of the city and his daughter should stick to their traditions. The huge façade of Haydarpaşa is the backdrop of the scene where the elderly father collects and directs the family to the ferry. In both stories of arrival, the plots revolve around the seductive aspect of the big city, but the subtext of nostalgia for the traditional family is stronger in the Turkish version.

A decade later another cinematic family arrives at Haydarpaşa this time from Yozgat, a city in Central Anatolia. *Gelin/The Bride* (Ömer Lütfi Akad, 1973) repeats the iconography of the train arriving at the station, as the whole family alights from the train and faces the sea. Here the main character is the bride of the family, the wife of their eldest son. Her tragedy is foreshadowed when she holds her young son closely, showing him the ferries and the city. This film is a turning point in the tradition of migration films in Turkey as it was filmed in colour and did not simply dwell on nostalgia. In spite of the death of her son, the bride starts working in a factory and starts a new life in the city.

Haydarpaşa remained as the opening gate to the city until 1973, when Bosphorus Bridge was opened to the motor traffic on the 50th anniversary of the Republic as a symbol of modernity and urbanization. From then on, buses replaced trains as the major means of arrival from Anatolia, both in real life and in films. However, Haydarpaşa recently reappeared in cinema as the form of a different threshold. *Hiçbiryerde/Innowhereland* (Tayfun Pirselimoğlu, 2002) portrays the station with a new symbolism, as the starting point of a nightmarish search into the unknown depth of Anatolia. *Anlat İstanbul/Istanbul Tales* (Ümit Ünal et al., 2004) is another example, where Istanbul becomes a claustrophobic location of different sorts in five episodes, each told by a different director. In one of the episodes the protagonists arrive at the station by ferry, from the European side, to flee from the city.

Today, Haydarpaşa is no longer celebrated as the iconic threshold of a city full of promise but as a nostalgic reminder of the heyday of black and white films. In contrast to its image in those popular films, in contemporary arthouse cinema it represents the subversion of hopeful arrivals. ✢

film have become the stereotypes of a genre in Turkish cinema, known as 'inner migration films'. Haydarpaşa Train Station, where the newcomers are both seduced and intimidated by the city, is an icon of this genre.

The best-known example of this genre, *Gurbet Kuşları/Birds of Exile* (Halit Refiğ, 1964) was inspired by Luchino Visconti's classic *Rocco and His Brothers* (1960). Similar to Visconti's film, which tells the story of a rural Italian family led north of Milan by the matriarch, *Birds of Exile* is a story of an extended family led from Maraş in eastern Turkey to Istanbul by the patriarch. Both families disintegrate as they struggle to adapt to the industrial city. Both films start at train stations, and they portray the stairs of the stations as the threshold of a new life. Haydarpaşa Train Station, however, is more cinematographic since it offers a vista of the sea and the city as a whole. The patriarch sets the rules as soon as they go out of the door facing the sea: his sons are not al-

Haydarpaşa remained as the opening gate to the city until 1973, when Bosphorus Bridge was opened to motor traffic on the 50th anniversary of the Republic as a symbol of modernity and urbanization.

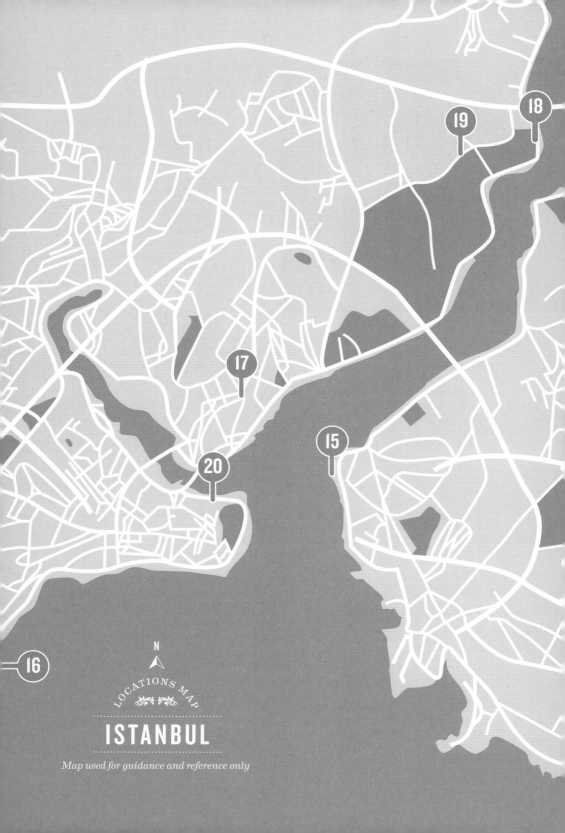

LOCATIONS MAP

ISTANBUL

Map used for guidance and reference only

ISTANBUL LOCATIONS

SCENES 15-20

LOVERS OF LEANDER'S TOWER/
KIZ KULESİ AŞIKLARI (1994)

The Maiden Tower

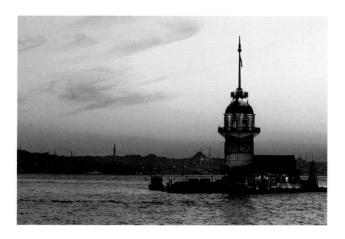

LOVERS OF LEANDER'S TOWER opens with a boy throwing stones into the sea towards the Maiden Tower from the shores of Salacak. An old man approaches him and asks what he is doing and the boy replies: 'I will build a path in the sea to go to the tower!' The narrative is based around the romance and lust between an elderly poet and the daughter of the former keeper of the lighthouse, who 'haunts' the site. As one of the signifiers of Istanbul, the Maiden Tower appeared in many films, including *The World is not Enough* (Michael Apted, 1999), but only from outside. The tower, for many years, stood there for many Istanbullites with its mysterious appearance, as it was not accessible to the general public. Although the film received negative critical reviews, what makes *Lovers of Leander's Tower* interesting is that it was the first film to take its audience inside this tower, which is on a tiny island off the Asian coast of Istanbul. On its website, this unique tower (originally used as a customs station controlling the entrance to and departure from the Bosphorus) is introduced with its 2500 years of history and for having witnessed everything that Istanbul has encountered throughout its history. Yet, according to one of the legends disseminated about the tower, the lighthouse was built by a sultan to keep his daughter in isolation from her lover. It was with this film that the tower was seen from inside. Today, the tower can be visited by the general public as it was sold to a private investor and was turned into a restaurant and café. ➤**Eylem Atakav**

(Photos ©Zehra Derya Koç)

Directed by İrfan Tözüm
Scene description: A young boy throwing stones towards the Maiden Tower
Timecode for scene: 0:00:01 – 0:00:35

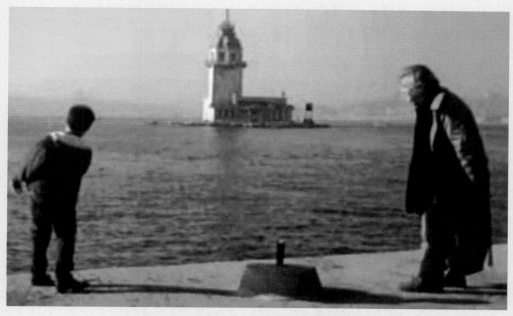

C BLOK (1992)

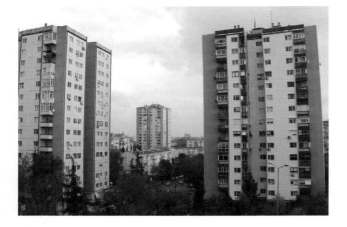

C BLOK tells the story of Tülay (Serap Aksoy), a middle-class woman, who lives in a flat in one of the city's tall apartment blocks. She is trapped not only in the city, but also in her marriage. The film can be read as the story of repressed sexual desires imprisoned in the architecture of modern everyday life, as well as of a marriage that is falling apart due to lack of communication. In this particular scene Tülay sees her cleaning lady having sex in her apartment with Halit (Fikret Kuşkan), the concierge of the building, with whom she will develop an unusual relationship later on. Having seen the couple, Tülay goes outside, where nothing but high-rise apartment blocks are to be seen. The scene is set in Ataköy, which is the signifier of the shifting and emerging residential patterns since the late 1980s in Istanbul. These residential constructions, which also include the first shopping mall built in Turkey, were seen as a signifier of modernization and urbanization. Yet, as the film suggests, perhaps these buildings are what trap individuals in a rapidly changing city. The film uses the city as a metaphor for prison. 'Block C', where the protagonist resides, is suggestive of titles given to cells in prisons. Through the use of frame within a frame technique, the characters are surrounded by the buildings around them, which enhances the claustrophobic feeling conveyed throughout the film. ⟿ ***Eylem Atakav***

(Photo ©Umut Türem)

Directed by Zeki Demirkubuz

Scene description: Tülay goes out in Ataköy

Timecode for scene: 0:10:15 – 0:11:30

 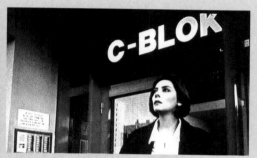

THE BANDIT/EŞKIYA (1996)

LOCATION

Doğan Apartment terrace, Tarlabaşı, Beyoğlu

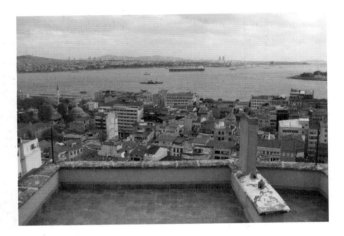

THE BANDIT, director Yavuz Turgul's biggest box office hit, tells the story of an old 1960s bandit, Baran, from the eastern part of Turkey, against the background of 1990s Istanbul. After spending 35 years in prison, Baran comes to Istanbul in order to find his lover, Keje, who is now the silent captivated wife of a former bandit and friend of Baran. A young streetwise and small-time criminal called Cumali accompanies Baran in Istanbul, in a city in which he feels claustrophobic much of the time. Almost all exterior scenes are shot on location, among them the view from a small hotel terrace is perhaps the most inspiring for Baran. Reminiscent of the mountains where he and his gang used to operate, this terrace functions as both a watch tower and a shelter for him. Baran's tales about his past and his outsider look on modern Istanbul posits him almost as a mythical and wise hero. On this terrace, he and the camera gaze into faces in the crowds through binoculars, as he tries to spot Keje in an almost shamanic trance-state with his arms (and other senses) open. In the finale, Baran disappears into the sky as a dying bandit from this terrace. The chosen scene also takes place on this terrace. Notwithstanding the guilt-driven complaints of Cumali about Istanbul, Baran goes into a euphoric state by almost trying to hold the city in his arms. Intertwined with meditative thoughts on the resemblance of Istanbul to the mountains, accompanied by a self-reflexive camera that follows him from behind, he shouts: 'It is as if I am on the heights of Cudi.' **Canan Balan**

(Photo ©Melis Behlil)

Directed by Yavuz Turgul

Scene description: Baran looks at the city from a terrace

Timecode for scene: 0:30:00 – 0:30:36

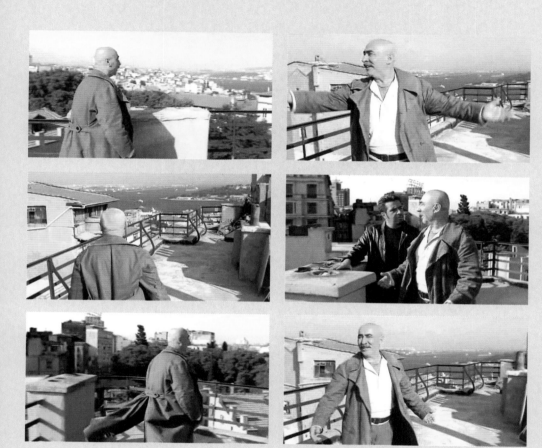

SOMERSAULT IN A COFFIN/ TABUTTA RÖVAŞATA (1996)

LOCATION *The Rumeli Castle, Istanbul*

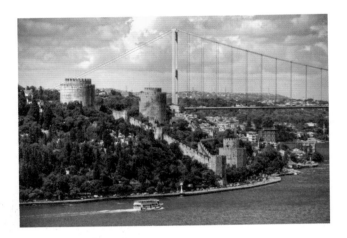

DERVİŞ ZAİM'S FEATURE DEBUT *Somersault in a Coffin*, a tragicomic drama based on a true story, is widely regarded as a milestone in Turkish cinema. The protagonist Mahsun Süpertitiz (Ahmet Uğurlu) is a homeless drifter and a petty criminal living on the streets of the Rumelihisarı district in Istanbul. This docile and gentle character is notorious for stealing cars at night to shelter from the cold winter. After driving around the city all night, each time he returns the car at dawn to the place where he had taken it. In tune with his last name Süpertitiz, which literally means 'over-fastidious', this meticulous and respectful thief always cleans and polishes before returning the car. Nevertheless, he is often in trouble with the police. In this scene we see Mahsun walking into the castle, but the guard stops him and tells that entrance is no longer free, because the castle has been turned into a tourist attraction housing several dozen gorgeous peacocks. The prohibition implies Mahsun's in-betweenness in the social space. So he scales the fence surrounding the castle and captures one of the beautiful birds to make it a companion in his nocturnal car joyrides. This ironic moment is followed by a second visit when Mahsun is desperately hungry. Once inside, he runs after the birds and takes one of them for a meal. While cooking the bird in the castle the guard notices smoke coming from inside and runs after Mahsun. The Rumeli Castle, a fifteenth-century Ottoman fortress near the Bosphorus, with its visually stunning atmosphere, appears in the film as an anachronistic gesture to allow the spectator to explore different modes of conversation with the haunting shadows of history and the secret persona of the city. **•◦Cihat Arınç**

(Photo ©Aydın Sertbaş)

Directed by Derviş Zaim
Scene description: Mahsun Süpertitiz running after the peacocks in the Rumeli Castle
Timecode for scene: 0:38:17 – 0:40:58

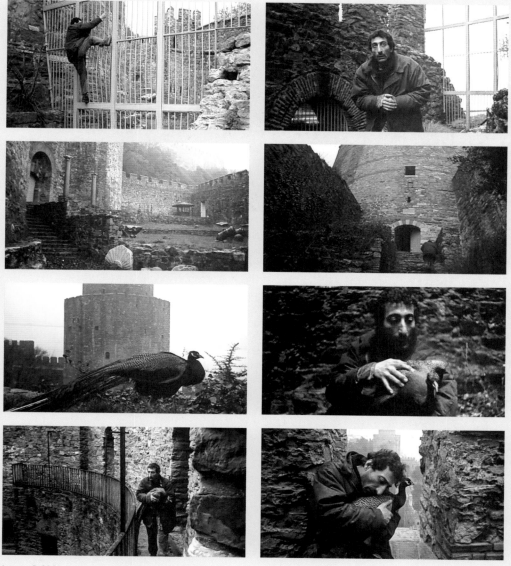

STEAM: THE TURKISH BATH/HAMAM (1997)

LOCATION *Akmerkez, Etiler, Istanbul*

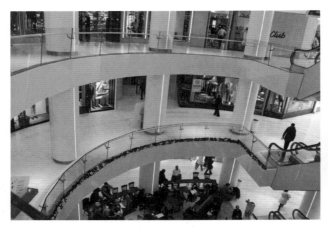

MARTA, THE ITALIAN LEAD FEMALE of *Hamam* (played by Francesca d'Aloja), leaves the cosmopolitan world of Rome, and a house run by Filipina maids, and gets inserted into a life of the orient, in a rundown neighbourhood of Istanbul. There, she encounters what is seemingly depicted as Turkish culture: selfless friendships, a loving home, chattering women, and an Istanbul with crooked, narrow streets inhabited by dilapidated buildings and colourful clothes hung between buildings and left to dry. Less like Rome but perhaps resembling the poorest sections of Naples. In this scene we follow Marta out of the familiar Istanbul of the Orient to face the brisk modernity of the city, while she sturdily rides the escalator in the pristine environs of a shopping centre, the contemporary temple of consumption. By way of Marta's excursion we learn that the city has many faces, not only a *hamam*, a metaphor for what is lost, but a shopping centre, a reminder of what is up and coming. The shopping centre appearing in this scene, Akmerkez, was one of the first high-end shopping centres built in Istanbul and attracted the local *flâneurs* for a long while as a place to see and be seen. The image of the woman on the escalator is also the sign of a shift in imagining Istanbul, a city incorporated into the new version of modernity that had come to refashion the world as we know it. The new Istanbul is no longer confined to the imaginary of the Orient, and modernity is not a vestige appended to a place characterized by nostalgia for the days gone by. The modernity of the woman on the escalator is the mundane of everyday. And the hamam she decides to own and run awaits not the locals but tourists fascinated by the charms of the city, as is expected. ➻*Levent Soysal*

(Photo ©Umut Türem)

Directed by Ferhan Özpetek
Scene description: Marta goes to a shopping center
Timecode for scene: 1:01:07 – 1:01:37

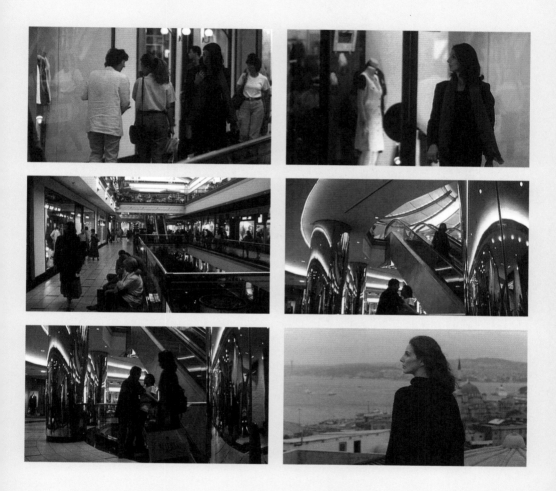

JOURNEY TO THE SUN/
GÜNEŞE YOLCULUK (1999)

LOCATION ⟩ *Eminönü*

THE FIRST NIGHT SCENE of *Journey to the Sun* is also the scene where Mehmet and Berzan meet for the first time. Prior to this scene we see the Galata Bridge and the Süleymaniye Mosque as the sun sets, an image reminiscent of the touristic postcards. This idyllic image is followed by a cut to a smoke-ridden local coffee house (traditionally exclusively for men) where excited men are watching the Turkish national football team on television. Unlike the rest of the crowd, who are eagerly waiting for the Turkish team to score, Mehmet's eyes reveal not excitement but rather an anxious curiosity, and instead he appears to be trying to 'go along' with the majority. The scene successfully illustrates Mehmet's discomfort at being pulled in, almost forcefully, to celebrate with the majority. This is also the reason why this particular scene stands out from many of the Istanbul films dealing with immigrants: the city is represented not as a place that pushes newcomers to its peripheries but as a place that forcefully pulls those individuals in and renders them invisible. What follows is a street fight where the same crowd attacks a Kurdish driver in his car for not joining in the celebrations (as it appears the Turkish team has won the game) as Mehmet and Berzan try to defend the driver. As a result of the assault Mehmet (from western Turkey) and Berzan (a Kurdish citizen from the east) take refuge in an old building. It is with this scene that the idyllic image of Eminönü we have just seen departs from our memory and Istanbul reveals its other side to its audience: a city that can swallow its inhabitants. ⚫**Fırat Yücel (text translation by Özlem Köksal)**

(Photos ©Zehra Derya Koç)

Directed by Yeşim Ustaoğlu

Scene description: Mehmet goes to a coffee house

Timecode for scene: 0:06:46 – 0:08:56

MEMORIES OF ISTANBUL

Text by UMUT TÜMAY ARSLAN

ISTANBUL, from the 1950s onwards, has been the main locale of popular imagination, during which the project of creating an 'imagined community' was on its way to success. For the rest of the country, even for those living in the capital Ankara, Istanbul meant *the* city. However, and somewhat surprisingly, Istanbul not only symbolized the seductiveness of modernity but also suggested a strong sense of loss, which almost always accompanies the alluring features of this modern city. The city was imagined as both the modern, western face of Turkey as well as being at the border of that place called the West.

One of the best examples of this duality appears in Atıf Yılmaz's *Ah Güzel Istanbul/ Oh Beautiful Istanbul* (1966). The film opens with protagonist Haşmet, a nostalgic man in his forties, watching Istanbul with sadness: 'Oh beautiful Istanbul,' he says, 'your beauty of thousand years… You pierced my ancestors' hearts, as you do mine.'

Through Haşmet's story the film tells the story of the promises of the modern world along with a sense of the loss those very promises created. It is for this reason that there are two versions of Istanbul in the film: one is the world in which the nostalgic protagonist lives, as he longs for his family's glorious past, the other is the city where 'all that is solid melts into air', a stage on which to become someone else. The film produces its main tension from this duality, from the encounter between Hasmet who is stuck in the past and fell outside of time, and Ayşe who came to Istanbul to become an actress, who is eager to keep up pace with the changing times.

Haşmet's Istanbul consists of his memories of the city. Istanbul, from his point of view, is heartbreakingly beautiful: as the traditional Turkish music plays and the whistles of ferries

and seagulls are heard, an acoustic mirror of the past is created. This image of Istanbul as an acoustic mirror also exists in literature, as does the dominating sense of loss. Ahmet Hamdi Tanpınar, one of the most prominent authors in the Turkish language, writes in his book *Five Cities* that this sense of loss started when the disappearance of traditional/local ways of life began. Orhan Pamuk later agrees with his predecessor in his memoirs, and writes that Istanbul is dominated by a feeling of melancholia (*hüzün*). As Pamuk reveals the city in which he grew up as a young boy, a black and white image of Istanbul appears: its streets, poverty, deprived mansions, old mosques, ferries with smoke coming out of their chimneys, are among those details that turn the city into a black and white photograph from the past.

Another film concerning itself with this black-and-white texture of the city was Memduh Ün's *Üç Arkadaş/Three Friends* (1958) which opens with an aerial view of the Galata Tower and the Galata Bridge, followed by a shot of a deserted, run-down mansion, in which our three protagonists, the newcomers of the city, are taking shelter. As the three friends walk by the Bosphorus, seagulls, traditional coffee houses and ferries enter into the frame. This picturesque image of the city; a melancholic gaze directed at the city, is often compared to the gaze of a lover looking at his/her object of desire.

What is more, in both *Three Friends* and *Oh Beautiful Istanbul* the despair that the characters find themselves in is always accompanied by scenic images of Istanbul. This melancholic image of the city is perhaps best represented by the (now disappeared) mobile photographers of Istanbul taking pictures in front of a curtain, which reads 'memento of Istanbul' (*Istanbul Hatırası*). Perhaps the

1955 against the non-Muslim population of Istanbul) includes an Armenian character Monsieur Artin Dartanyan, and looks for ways to cherish the Istanbul that belongs to the Artins as well as the Haşmets. Ten years after *Three Friends*, *Oh Beautiful Istanbul* writes out this part of history and imagines a city that belongs to the Haşmets and the Haşmets only.

In this melancholic relation to the city, the image of 'lost Istanbul' becomes something indescribable, an image that points to a larger loss: for some it signifies what is lost in the process of becoming a unified nation, and for others a mystical past. However, what this dominant feeling of melancholia does not reveal is the inherent belief in the Turkishness of the city and the clash it creates with the city's history, namely the existence (and the disappearance) of its non-Muslim population. This unnamed loss, on the one hand, is the history of the nation and on the other a loss of a hybrid body: a city that belongs to not only Muslim Turks but also to Armenians, Greeks, Jews and others. The trope of melancholy in Turkish cinema, it seems, is built on the understanding that this loss is not to be talked about. However, the repressed always finds its way into this frozen image of the beloved.

Metin Erksan's *Sevmek Zamanı/Time to Love* (1965) makes this melancholic attachment visible in the story of Halil, a man who falls in love with a photograph of a girl. The relation between the image of Istanbul and the image of the beloved here reveals itself in 'love at last sight'. Foggy streets, ruins scattered around the city, a huge black and white picture of the beloved, along with the protagonists' shadowy images, surround the film with an inescapable sense of melancholia as this impossible love story is shared with the city itself.

continuity between how these melancholic films represented Istanbul and how they are received today, as they themselves became 'mementos of Istanbul', should be sought here: these films, themselves nostalgic about the past, provide us with an image of Istanbul that no longer exists today (and possibly never did).

When examining how such melancholia is produced and experienced, Orhan Pamuk states that there is a mixture of pride, arrogance and reluctance in this melancholic relation to the city. Another point Pamuk raises is that this gaze directed at Istanbul, which is imagined to be coming from within and belonging to the locals, is in fact also shaped by the likes of Melling, Nerval and Gautier.

It is in this particular image of Istanbul, which remains Turkish/Muslim while being western, that the tension is created as the question of identity is softened with a hint of 'us' , as it was imagined by the newly established republic. This image was also reproduced and popularized in film. However, the differences between *Oh Beautiful Istanbul* and the *Three Friends* are as important as their common tropes. *Three Friends* (made three years after the infamous pogrom of 6 and 7 September

> **Istanbul not only symbolized the seductiveness of modernity but also suggested a strong sense of loss, which almost always accompanies the alluring features of this modern city.**

The feeling of failure or incompleteness, that is also the unavoidable destiny of the image, is also the starting point of *Time to Love*. The image of Istanbul as a melancholic city never leaves the frame as the film makes us aware that falling in love with an image stems from a fear of loss that also determines the city's representation on screen. As a result, the image of Istanbul frozen in time ends up re-producing the loss from which it was trying to move away. ✤

(Text translation by Özlem Köksal)

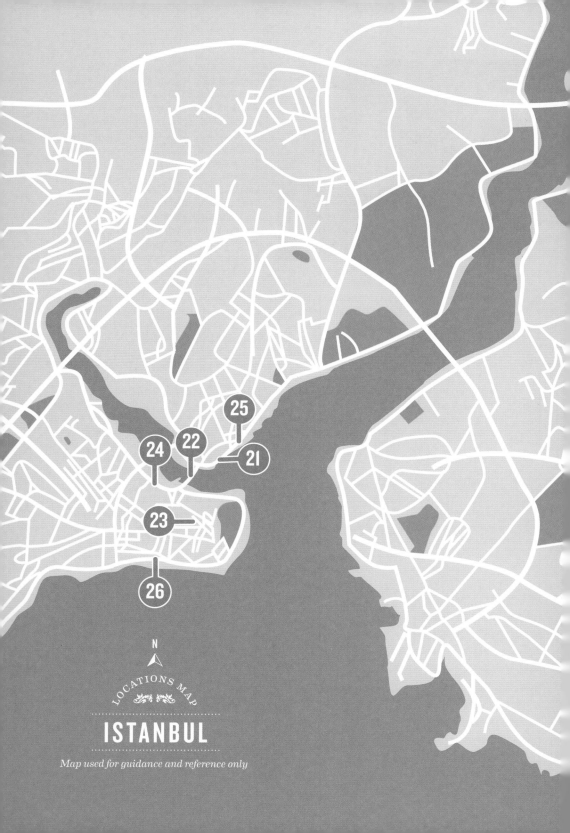

N

LOCATIONS MAP

ISTANBUL

Map used for guidance and reference only

ISTANBUL LOCATIONS

SCENES 21-26

A RUN FOR MONEY/KAÇ PARA KAÇ (1999)

Karaköy ferryport

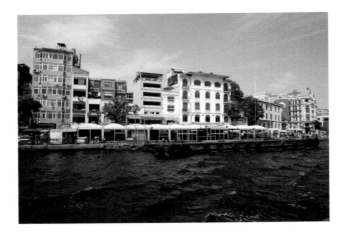

REHA ERDEM'S *A Run For Money* revolves around the moral dilemma of the protagonist, Selim (Taner Birsel), after finding a bag full of money in a cab. Although Selim is known for his absolute honesty among his friends and family, he crosses the line for the first time in his life, and does not return the money, which turns out to be stolen in the first place. From that day on, Istanbul becomes a scene, and a metaphor, for Selim's in-betweenness. In fact, the chasing sequence on the ferry might be considered as the materialization of Selim's entrapment in his moral dilemma. The sequence opens with Selim taking a seat on the boat for his routine journey to his workplace, from Kadiköy to Karaköy Tunel. A few seconds later the camera cuts to the man who forgot the bag in the cab. As they recognize each other, Selim leaves the room in a stew and goes to the deck, but this time runs into the thief who robbed his shop. While the man runs after Selim, the thief runs away from him. A breathtaking triple chase begins on the ferry, which turns it into a labyrinth where the guilty and victim are intertwined. The fast pace editing, together with series of short takes and cuts to each one's stampede in tight framings, is enhanced with the rhythm of the music that brilliantly increases the tension and creates a claustrophobic atmosphere, making the audience feel Selim's panic and entrapment. The extreme long shot of Selim running in the background of an Istanbul skyline, after the ferry's arrival to Karaköy port, establishes Selim as a tiny figure, lost in fear and entirely alone, in Istanbul. ⇢ *Özlem Güçlü*

(Photos ©Zehra Derya Koç)

Directed by Reha Erdem
Scene description: Selim is chased on a ferry
Timecode for scene: 0:52:13 – 0:58:05

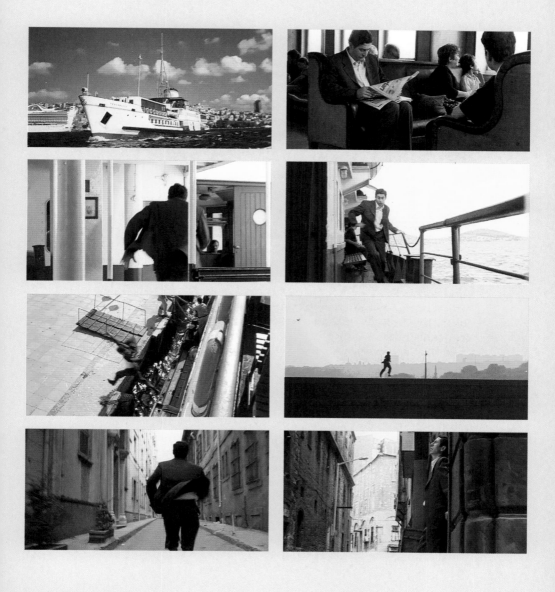

THE GIRL ON THE BRIDGE/
LA FILLE SUR LE PONT (1999)

LOCATION *Galata Bridge*

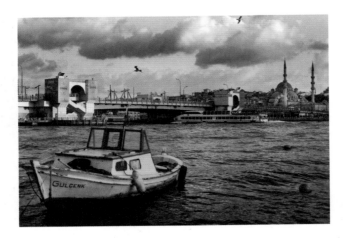

SHOT BEAUTIFULLY in black-and-white, *The Girl on the Bridge* is a film that starts and ends on bridges. The film opens on a footbridge over the Seine in Paris where Adèle (Vanessa Paradis) and Gabor (Daniel Auteil) meet for the first time. Adèle is about to commit suicide but Gabor convinces her to become the target of his knife-throwing show instead. After travelling from one venue to another, the film takes a complete detour and ends on another bridge in Istanbul. Connecting the imperial town on the right bank to the modernized residential area on the lower Bosphorus, the Galata Bridge was originally built in 1845 – the current bridge had replaced the fourth one in 1994. Towards the end of the film, the relationship between Gabor and Adèle ends abruptly when she runs away with a newly-wed groom. Soon Adèle is strolling on her own in Athens, while Gabor ends up broke in Istanbul. In this very last scene, we see a destitute and heart-broken Gabor limping on a bridge in Istanbul. Life without Adèle turns out to be a misery, so he is about to end it. He crosses the parapet and is ready to jump into the water, at which point Adèle shows up. Mirroring the first bridge scene, this time it is her who saves Gabor. After a rapid montage of the couple's embrace, the camera unsteadily dollies out on a boat. At this point Galata Bridge becomes recognizable, as it is only now, after a number of disorienting extreme close-ups, that the bridge is seen at a distance, in front of the magnificent silhouette of Istanbul. The iconic entry point to the city marks a new beginning for Gabor and Adèle. **→Ahmet Gürata**

(Photos ©Zehra Derya Koç)

Directed by Patrice Leconte
Scene description: Gabor is ready to jump off the bridge
Timecode for scene: 01:20.20 – 1:26.30

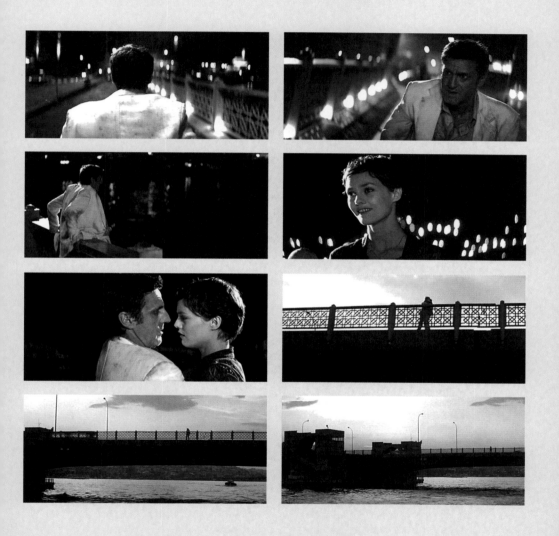

THE ACCIDENTAL SPY (2001)

LOCATION

Çemberlitaş Hamamı, Spice Bazaar and Grand Bazaar

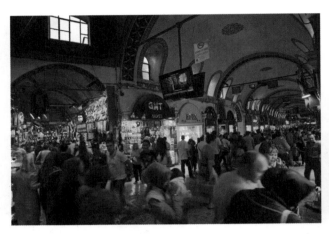

THE ACCIDENTAL SPY is an international thriller set in Hong Kong, Korea and Turkey. In the movie Jackie Chan has enormous tasks before him: solve a riddle, assist the CIA, save a woman and a child, and fight off an army of bad guys – all single handedly. Buck Yuen is a typical Jackie Chan character: naive and clumsy, but a born survivor with sound instincts. While trying to unravel a riddle, Buck arrives in Istanbul. After a series of ordeals, he manages to lay claim to his father's inheritance: a suitcase full of cash. However, by this point, he finds himself in the midst of an international conspiracy. Unaware of the impending danger, Buck enjoys a massage and steam bath at the Çemberlitaş Hamamı. In this hamam, historically one of the finest of its kind, he is attacked by a group of thugs. Luckily, Buck manages to escape onto the hamam's roof (which is in fact the roof of the Grand Bazaar). Escaping with an umbrella, he arrives at the bazaar. Shot in the Grand Bazaar and Spice Bazaar, this is one of the funniest scenes in the entire Jackie Chan filmography. While fighting, Buck loses his hamam towel. Now he faces a more difficult task: in front of a crowd of onlookers, he has to make an escape while keeping his private parts covered with whatever is at hand. Finally reaching an alleyway, Buck manages to disguise himself with a makeshift chador, which he acrobatically whips into shape from a huge white piece of cloth hanging from above. Obviously this incredible escape pushes the limits of believability, but Chan's trademark martial arts stunts and antics provide for a scene that is memorably hilarious. **↝Ahmet Gürata**

(Photos ©Zehra Derya Koç)

Directed by Teddy Chan
Scene description: Buck runs naked in the bazaar
Timecode for scene: 0:36:58 – 0:42:25

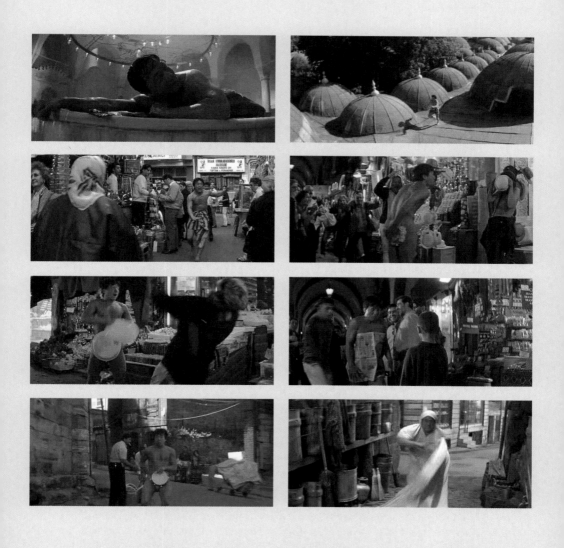

A TOUCH OF SPICE/POLITIKI KOUZINA (2003)

LOCATION *Sultanahmet Square*

A TOUCH OF SPICE is about the story of young Fannis (Georges Corraface), and his family who are living in Istanbul, and is based on the director's own experiences as a Greek Istanbullite. Fannis spends most of his time in the dream-world provided by his grandfather's spice shop located in Kadıköy. When a crisis between Greece and Turkey, yet again, occurs in the 1960s his family is deported, as his father is a resident in, but not a citizen of, the country. The director's portrayal of Istanbul surrounds his characters, as well as his audience, with senses: audio and gustatory knowledge is played upon in order to evoke memories of a place. However, strangely enough, Istanbul does not appear with its physical beauties in the first part of the film where Fannis' memories of the city are being portrayed. It is only after his return to Istanbul in his forties that the director shows landmark images of Istanbul that are dominated by a heavy sense of nostalgia. In this particular scene Fannis meets his childhood sweetheart Saime (Başak Köklükaya), who works as a tour guide. The meeting takes place in front of the German Fountain (*Alman Çeşmesi*) in one of the most visited locations by tourists: Sultanahmet Square (Hippodrome) where Topkapı Palace, Hagia Sophia and Blue Mosque are located. This specific location is more than appropriate for a scene where Fannis lets Saime know that he will be staying in Istanbul for a while as a tourist. He returns to Istanbul, to the city where he was born, as a visitor and the contrast between his relation to the city as a child and as an adult is illustrated particularly well in this scene. **➛Özlem Köksal**

(Photos ©Zehra Derya Koç)

Directed by Tassos Boulmetis
Scene description: Fannis meets Saime
Timecode for scene: 1:26:17 - 1:30:54

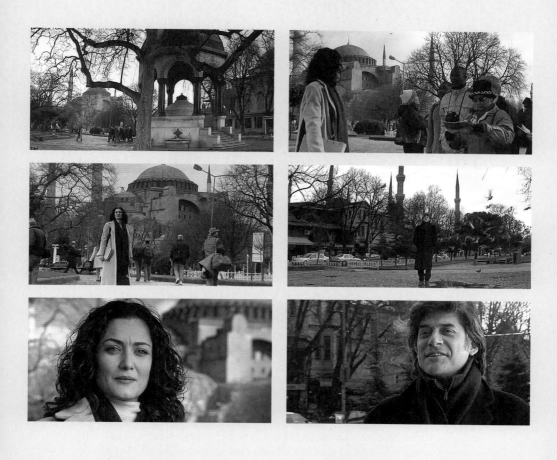

HEAD ON/GEGEN DIE WAND (2002)

LOCATION *Haliç*

HEAD ON IS THE STORY of two second-generation Turkish-German characters from Hamburg, Cahit and Sibel, both going through a self-destructive phase of their lives, giving themselves up to different escapes. Living in a messed up alcoholic state, Cahit (Birol Ünel) has no intention to lead a normal life while Sibel's (Sibel Kekili) suicide attempts are evidently induced with the pressures of her traditional first-generation Turkish immigrant family in Germany. They do not have any initial interest in the suffering they see in each other, but then they fall in love. Fatih Akın's choice of narration for the unconventional melodrama in *Head On* is peculiar. From the beginning onwards, Akın interferes with the plot and subtly comments on the fate of the protagonists with a completely different scenery, out of the narrative world. There we are, by the side of Golden Horn (Haliç), with a Turkish classical music ensemble performing to the camera, on a ground covered with Turkish carpets in a photographic *mise en scène*. At one of the most iconic landscapes of Istanbul's silhouette, timeless and displaced, these repetitive independent scenes evidently comment on how identity (Turkishness) and the past (of Istanbul) is imagined, with their traditional and stylized aesthetics. Although they serve for a self-conscious underlining of the excessive sentimentality at first, they soon become a convention reminescent of the traditional Turkish performing arts where such distancing effects create a dialogue with the audience. This is pretty much the intricacy Akın relies on. In *Head On*, classical melodrama takes a rebellious twist towards the credibility of forging one's self through love. ➡ *Övgü Gökçe*

(Photo ©Zehra Derya Koç)

Directed by Fatih Akın
Scene description: A traditional musical ensemble plays
Timecode for scene: 0:16:05 – 0:17:05 (repeated at various intervals in the film)

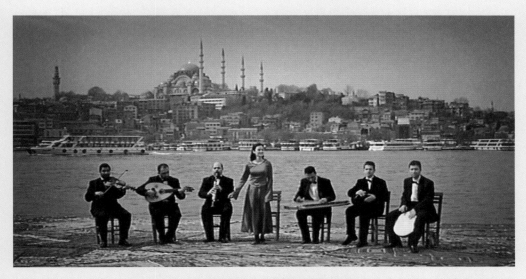

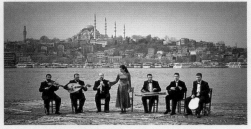

ANGEL'S FALL/MELEGIN DÜSÜSÜ (2004)

LOCATION *Kumkapı Train Station*

THE LOCAL TRAINS of Istanbul are depicted as a symbolic carrier between the lonely, unhappy life of Zeynep (Tülin Özer) at the outskirts of the city and the outside world, presented as an amalgam of mysticism and escape. Zeynep, a chamber maid in a hotel, lives with her father who sexually abuses her. Throughout the movie, her desperation is embedded in Kaplanoğlu's minimalist, calm, and plain cinematic narration. There are subtle hints that the story takes place in the 1990s. For instance, Zeynep lines up to pick up a kitchen blender that newspapers gave out for free in exchange of coupons in those days, and Zeynep's father, in a rare conversation with his daughter, warns her about the rumours of an approaching earthquake, which did shatter the city in 1999. This scene towards the end of the film, where Zeynep stands at Kumkapı train station with luggage, brings an unexpected twist to the plot. The luggage contains the donated cloths of a woman who died in a car accident and leads to a climactic and cathartic violence. The camera always focuses on the angelic face of the main character and sheds a light on her face while riding on the train. In contrast with the dark interior shots where silent tragedies take place, Zeynep always looks out the train window rather peacefully. Local trains have always been a way of transportation for the working class people in Istanbul. Kumkapı train station is one of the oldest ones that is still in use today, and is accompanied by the beautiful landscapes of Eminönü and Galata Bridge in the background of *Angel's Fall*. **⇥ Aslı Tunç**

(Photo ©Umut Türem)

Directed by Semih Kaplanoğlu
Scene description: Zeynep waiting for a train
Timecode for scene: 1:01:45 – 1:01:57

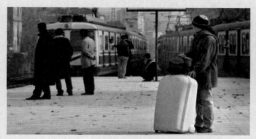 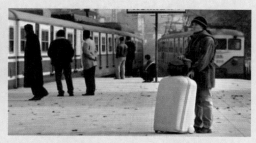

ISTANBUL DISSECTED

The City Through Reha Erdem's Lenses

Text by
YEŞİM
BURUL
SEVEN

REHA ERDEM is one of the most exciting and intriguing directors of contemporary Turkish cinema, not only because he tells us new and imaginative stories, but also because he makes films that invite us to look anew, through a different lens, at the most basic questions of human existence. In the hands of Erdem, an auteur who favours creating meaning through cinema rather than representing the supposed 'reality', Istanbul takes on quite a different form. Among his contemporary film-makers, Erdem has, by far, the quirkiest relationship to the city, using the city as a raw material from which to create appealing yet disorienting narratives.

According to Erdem, cinema should create a world of its own, hence decidedly refraining from capturing reality as it is. By resisting the continuity principle of editing, he emphasizes the artificiality of places and situations. Yet within his uniquely crafted

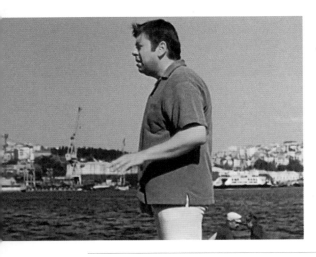

filmic space, Erdem manages to tell gripping and timeless tales of young girls who are prematurely forced to grow up and adult men who refuse to grow up. Out of the six films in his filmography, four of them are set in Istanbul, starting with his debut *A Ay* (1988).

A Ay, a fantastical first film shot in black-and-white, to an extent sets the ground rules for his films to follow, showcasing Erdem's peculiar engagement with the city. The film is largely set in two locations: the old, incomplete mansion by the Bosphorus in the Rumelihisarı district, and Burgazada, a small island of the Princes' Islands. The incomplete and decaying mansion, in many respects, embodies Istanbul and creates a sense of entrapment as well as being the source of hopes and fantasies for the main protagonist, the 12-year-old Yekta (Yeşim Tozan). Retrospectively, the director admits that he was actually revisiting and reflecting on his own childhood, re-creating the city on screen based on his own interpretation of it.

In his second feature *Kaç Para Kaç/A Run for Money* (1999), Erdem, once again, portrays an imagined Istanbul with empty old streets while the silhouette of the Golden Horn serves as a background. This touristic version of Istanbul, composed of Beyoğlu, Tünel and the historic peninsula, is slowly transformed into a nightmarish setting for this thriller-noir, and eventually brings about the destruction of Selim (Taner Birsel), the modest shopkeeper whose life takes an unexpected turn when he finds himself in possession of a large amount of money. However, the money, which he hoped would liberate him from his mundane life, becomes a different kind of chain to a different kind of

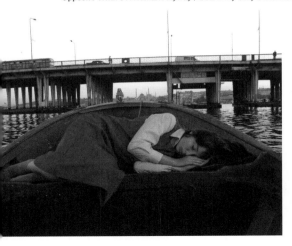

existence. Even the ferry he takes everyday to work comes to represent his entrapment. The only way-out for him is to disappear into thin air, like Yekta in *A Ay*, but even that is not possible for him.

The organization of space in Erdem's films forces us to reconsider our perception of the city. Be it the odd children in front of the closed shutters of shops in *A Ay* or the shop that seems to have come out of a previous decade of Istanbul in *A Run for Money*, the focus is always on certain aspects of the city that are singled out by the director himself. Therefore while he is creating his own versions of Istanbul, he also facilitates the emergence of a set of new Istanbuls in the imagination of the viewers. In *Korkuyorum Anne/What's a Human Anyway* (2004), for example, the image of the old classical Istanbul neighbourhood is set up craftily so that the outcome is an Istanbul that defies periodization and readymade categorization. While the apartment building used in the film is actually in Tophane, the relationships among neighbours and family members depicted in the film belong to a different

The organization of space in Erdem's films forces us to reconsider our perception of the city.

place and time, probably to an imaginary one. The sea surrounding Istanbul does not offer comfort or freedom in this film either, as it has not in his previous films. The childlike men of this film end up trapped on top of a huge rock by the sea, asking for their mums, creating, once again, a city with no way out.

In his *Hayat Var/My Only Sunshine* (2008), Erdem decides to look at the city from the level of the sea, depicting the life on the Bosphorus, with cargo-ships, ferryboats and other vessels constantly crossing its waters. Although the film begins with beautifully captured images of the Bosphorus, soon the claustrophobia sets in. This time it is the 14-year-old Hayat, played wonderfully by Elit İşcan, who is trapped in her dysfunctional family and shuts the cruel world out by humming to herself, as if comforting a baby. The film also creates an overwhelming soundscape of the city: the sound of sirens, whistles of ferryboats, screams of seagulls, and the constant coughing of Hayat's sick grandfather are not only the sounds dominating her life but also compose a cacophonic Istanbul. The beautiful scenery of the Bosphorus captured by Florent Herry, the regular cinematographer of Erdem, creates a striking contrast to the deprivation in which Hayat and her family live. Istanbul, as represented here, is not a welcoming place, not fair and definitely not comforting. Erdem's montages of Istanbul create new versions of this timeless yet beautiful city, forcing its audience to reflect on their own relationships with it.

My Only Sunshine concludes with Hayat leaving home with a boy, whom she has made sure is not from Istanbul, on a small boat which they have stolen. They ride into the vast blueness, enjoying their spontaneous freedom. Having found an accomplice in someone who is not ashamed of being an outsider, she rejects the narrative imposed on her in order to free herself from the constraints of the city and is now able to live in it. Through Hayat, Reha Erdem points out to a city that lies beyond our grip, so familiar yet so distant. This is also where Erdem's talent lies: his orchestration of Istanbul creatively disorients the spectators, forcing new angles onto the familiar. ✢

ISTANBUL

Map used for guidance and reference only

ISTANBUL LOCATIONS

SCENES 27-32

ISTANBUL TALES/ANLAT ISTANBUL (2004)

Spice Market, Pandeli Restaurant – Eminönü

ISTANBUL TALES turns the city into one of its characters, much like the original title (*Anlat Istanbul – Tell Me Istanbul*) suggests. The film modernizes five classic fairy tales, interwoven by Ümit Ünal's intricate script, with each segment directed by a different film-maker. Any scene would have been memorable for its use of the city, but the opening sequence of the 'Sleeping Beauty', where the 'knight in shining armour' arrives in Istanbul to find himself in the hustle and bustle of the historic Eminönü district, particularly stands out. The knight is Musa (Selim Akgül), a young Kurdish man fresh out of his military service, who has come to the big city to make a living. As he walks over the Galata Bridge and into the Spice Market, the audience is faced with the overwhelming intensity of the old city. But once the boy steps into Pandeli Restaurant on the upper floor of the market, the cool blue tiles of the old establishment convey an oasis of calm. This century-old institution is one of the best-known traditional restaurants of the city, carrying the weight of an elite Ottoman past. Musa heads straight to the kitchen to ask for a job from one of the kitchen staff, a man from his hometown. Simultaneously, characters from some of the other tales are in the dining hall: they are the rich and the powerful, in contrast to penniless Musa, who can barely speak Turkish. Istanbul, the city of contrasts, is laid bare in this historic location. ↝*Melis Behlil*

(Photos ©Zehra Derya Koç)

Directed by Ümit Ünal, Kudret Sabancı, Selim Demirdelen, Yücel Yolcu, Ömür Atay
Scene description: Musa arrives in Istanbul
Timecode for scene: 0:49:20 – 0:55:03

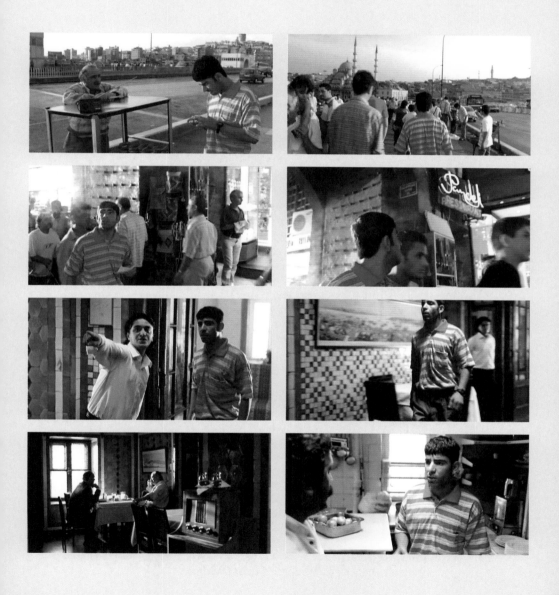

CROSSING THE BRIDGE: THE SOUND OF ISTANBUL (2005)

LOCATION *Bosphorus*

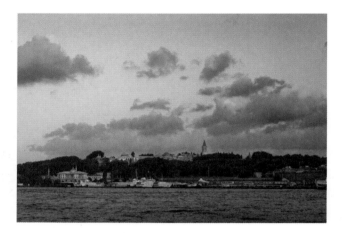

'**TO UNDERSTAND A PLACE**, you must understand the music made there': the first documentary by Fatih Akın starts with this quote from Confucius as the director sets on a journey to discover the secrets of the city through its sounds, particularly its music. Our musical journey starts with a neo-psychedelic band, Baba Zula, and offers us a rarely seen panorama of musical genres, ranging from classical Turkish music to Turkish rap, from experimental music to Kurdish laments, establishing a surprising harmony between the dizzying diversity of the music and the rhythm of the city. In this particular scene, which is also the closing sequence, Breanna McCrimmon is singing a Baba Zula tune with her touching voice, which the director decided to film on a boat over the waters of Bosphorus. In the middle of Bosphorus where it is neither Europe nor Asia, and at the time of sunrise when it is neither day nor night, the sun rises from the Anatolian side and crosses the Bosphorus. Playing with the fact that Istanbul is spreading into two continents, the film uses the bridge not only as metaphor but also as one of the characters in the film. This image of the bridge, while connecting the two continents, also enables the possibility of a coexistence of different voices. The spectator feels himself/herself on this very bridge, throughout the journey of Istanbul's sounds, as Istanbul is explored through its sonic variety. With this very last scene the film concludes with the recognition that the city remains a mystery and invites us to experience it through our senses, offering both the music and the sound of the waves and birds at the same time. **⇢ Özge Özyılmaz**

(Photo ©Zehra Derya Koç)

Directed by Fatih Akın
Scene description: Breanna McCrimmon sings on a boat over Bosphorus
Timecode for scene: 1:20:21 – 1:24:46

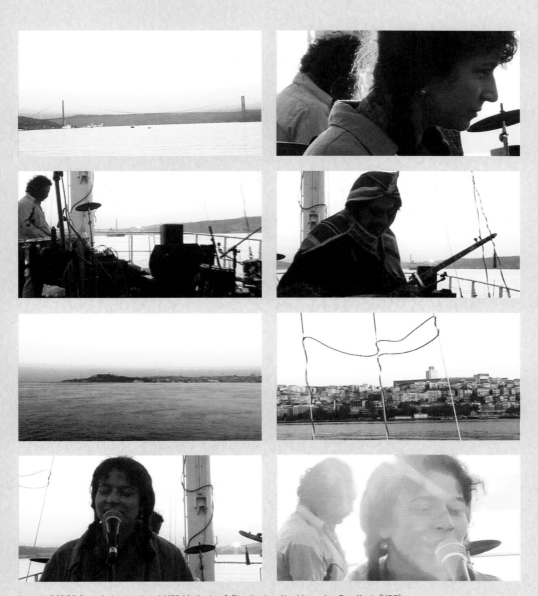

EDGE OF HEAVEN/AUF DER ANDEREN SEITE (2007)

LOCATION *Çukurcuma*

EDGE OF HEAVEN is divided into three chapters and takes place in Germany and Turkey. The film tells the story of six individuals, whose lives are interlinked in rather sophisticated ways. One of those characters is Sussane (Hanna Schygulla), who comes to Istanbul following her daughter Lotte's (Patrycia Ziolkowska) murder by a group of children on the streets of Çukurcuma, not far from where she was staying. Grieving for her daughter, she asks Lotte's room-mate Nejat (Baki Davrak) if she could stay in her daughter's room. In this short scene Sussane is seen sitting outside the building, waiting for Nejat to arrive. When Nejat arrives, she points to the decaying building next to the one they are staying in and asks why it has been left in such a state, to which Nejat replies: 'Corruption, car park mafia, cultural decay.' However, the third building in the frame tells us the same story from a different point of view: it is a renovated building, with a 'for-rent' sign on it. Çukurcuma, receiving a face-lift in recent years, has started attracting people like Nejat, who want a particular experience of Istanbul, but the process forced its previous inhabitants out, as it became unaffordable for them. It is no coincidence that Akin had his characters from Germany come and live in Çukurcuma, a vibrant, trendy and rapidly gentrifying neighbourhood. It is also no coincidence that it was this particular building he picked as Nejat's home: a handsome looking building next to a decaying and hauntingly beautiful one. In *Edge of Heaven* the streets of Çukurcuma are rendered legible, as the cultural and personal meanings of similar spaces shift from one individual to the other. The film overall is a response to the effects of globalization on individuals' lives and on the perceptions and cultural meanings of space. **↝Eylem Atakav**

(Photos ©Özlem Köksal)

Directed by Fatih Akin
Scene description: Sussane and Nejat are talking outside Nejat's flat
Timecode for scene: 1:35:33 – 1:36:07

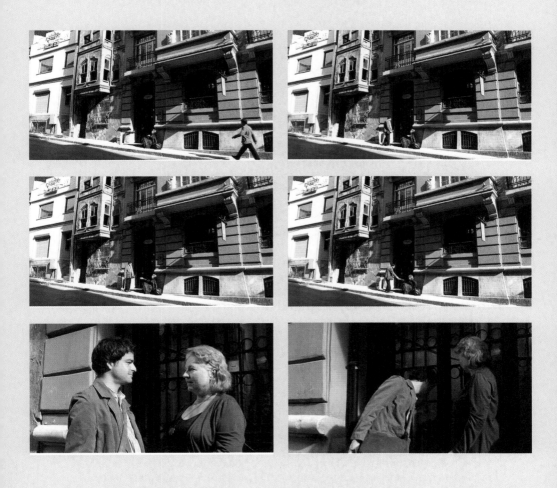

THREE MONKEYS/ÜÇ MAYMUN (2008)

Yoros Castle

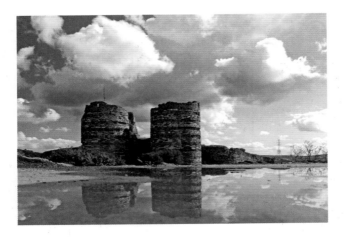

THREE MONKEYS tells the story of a dysfunctional family who are desperately trying to avoid their past and to cover the lies they told. The father Eyüp (Yavuz Bingöl) agrees to go to prison for a crime his boss Servet (Ercan Kesal) committed in exchange for a payment that could help the family's financial situation. While Eyüp serves time in prison, his wife Hacer (Hatice Aslan) develops feelings for Eyüp's boss and they briefly have an affair. However, when Servet ends the relation, Hacer finds it difficult to accept the situation and starts stalking him. In a rather cruel scene, shot in the Yoros Castle with a breathtaking view serving as the background, Servet threatens Hacer. Humiliating her in every possible way Servet demands her to cease all contact with him but Hacer refuses, constantly begging him. The scene places its characters among the ruins and it is the location itself, among other details, which determines the characters' faith: Servet, after this encounter with Hacer in this remote location, will be murdered by Hacer's son who followed them there. The use of space in *Three Monkeys* decidedly fails to provide a complete picture of the city, each location appearing to belong to a different mood and different story. The castle, in this scene, appears timeless and calm, unlike the perceived chaos that seems to be dominating the rest of the city. However, the calm it provides functions almost like a blank canvas for the director as he uses the location for one of the most humiliating scenes in the film, followed by (albeit off-screen) violence that ends Servet's life. Shot with almost no close-ups, the clue to the emotional tension of the scene is buried not in the characters' faces but in the space itself. ↪*Zehra Derya Koç (text translation by Özlem Köksal)*

(Photo ©Aydın Sertbas)

Directed by Nuri Bilge Ceylan
Scene description: Hacer meets Servet
Timecode for scene: 1:14:28 – 1:18:17

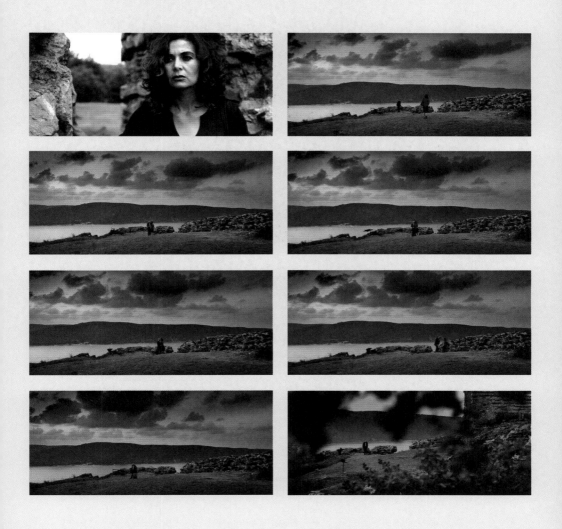

MY ONLY SUNSHINE/HAYAT VAR (2008)

Karaköy underpass

ISTANBUL and the waters of the Bosphorus play a crucial role in Turkish cinema. However, Reha Erdem's feature *My Only Sunshine* inscribes a unique sense of Istanbul with its almost surreal and deserted depiction of the city, and its beautiful but claustrophobic shots from the sea. Equally importantly, despite its highly dark and precarious atmopshere, it disrupts the gendered cliché of the Turkish cinema regarding the streets of Istanbul being dangerous for a single woman. The female protagonist Hayat (Elit İşcan) survives in the dark streets of Istanbul whilst danger and violence comes from the familiar as she is subjected to abuse and rape in her neighbourhood in the daytime. In this long sequence, where Hayat wanders around alone at night on the streets of Karaköy, the camera tracks her from behind, making her seem more vulnerable, resonating with the threatening eye(s) directed on her. The eerie background sounds of the city reminding her of the possible dangers awaiting her, raises further the sense of threat with every step she takes. However, when Hayat is halfway through the underpass tension is reduced with the fade-in of the Turkish arabesque music pioneer Orhan Gencebay's song 'Seveceksin', over these sounds, then it is completely released at the end of the sequence when Hayat comes through the dark and uncanny streets of Karaköy, against all expectations. Furthermore, Erdem's association of arabesque, a popular genre with the migrant subculture in big cities reflecting/projecting a macho sensibility, with a teenage girl's presence on the streets of Istanbul, subverts the gendered codes of arabesque culture. ➼ *Özlem Güçlü*

(Photo ©Zehra Derya Koç)

Directed by Reha Erdem
Scene description: Hayat wandering around Karaköy
Timecode for scene: 1.29.55 – 1.32.43

MY MARLON AND BRANDO/GITMEK (2008)

LOCATION *Küçükpazar, Fatih*

KURDISH DIRECTOR Hüseyin Karabey's first feature, *My Marlon and Brando*, takes place in three countries (Turkey, Iran and Iraq) on the verge of the war in Iraq in 2003. The story focuses on Turkish actress Ayça's (Ayça Damgacı) struggle to reach her Kurdish boyfriend (Hama Ali) in Northern Iraq (the Kurdish region). While trying to find a contact to help her get into Iraq, she meets Soran, a Kurdish refugee from Iraq who is hiding in Istanbul and hopes to make it into Europe. In this scene Ayça offers to look after a few paintings of Soran and they go to where Soran is staying. As they walk, the director cuts to a number of different shots, documenting the neighbourhood and its inhabitants with street vendors, run-down buildings and narrow streets. The moment of arrival for Ayça is a small shock as she is faced with a world that she has not encountered before. Soran lives in a small room shared with six others, in a single men's dormitory, a building that provides a temporary shelter for many displaced people like him. The scene is filmed in a small neighbourhood called Küçükpazar, located in the Fatih district of Istanbul. The neighbourhood, a historic but neglected area of Istanbul, is known for these types of accommodations as it provides cheap dormitory-like shelters with over crowded rooms for single men like Soran, who come to Istanbul for many different reasons. ◆◆*Mustafa Gündoğdu*

(Photos ©Özlem Köksal)

Directed by Hüseyin Karabey
Scene description: Ayça enters single men's dormitory
Timecode for scene: 0:28:50 – 0:30:20

BEYOĞLU/PERA

Text by
İPEK
TÜRELİ

on a cinematic map of Istanbul

CINEMA HAS PLAYED a special role in Istanbul, helping form the image of the city for both the city's residents and audiences elsewhere in Turkey and abroad. If a 'cinematic map' of Istanbul were to be drawn, Beyoğlu/Pera would occupy its centre. The district hosted the first film screenings (1896), the first (1908) as well as the most prestigious movie theatres along its main artery Grand Rue de Pera (İstiklal or Independence Avenue). Most film businesses were located here, especially on Yeşilçam Street during the heyday of Turkish cinema (1950s – mid-1970s).

Pera, which means 'on the other side' in Greek, was physically across the historic peninsula, on the other side of the Golden Horn. 'Beyoğlu' which literally means the son of a *bey* (or chieftain/lord), was the name Ottoman Turks had preferred for Pera, and after Turkification, came to be exclusively used. Beyoğlu was originally the diplomatic and financial district; embassies and banks were located there when Istanbul was the capital of the Ottoman Empire. In connection, a vibrant trade, cultural, and entertainment life developed and impressive multistory buildings lined and surrounded İstiklal Avenue.

Predominantly non-Muslim minorities and Levantines (Europeans residing in the Levant, the eastern Mediterranean) lived in the wider district well into the twentieth century. As Zeynep Çelik (1993) also notes, as a consequence of European connections, Beyoğlu was the district subject to the first modernization efforts and municipal reforms of the nineteenth century and came to be often contrasted with traditional neighbourhoods in the historic peninsula in literary and cinematic representations of the city, that dealt with the predicaments of modernization. It was the entertainment centre of the whole city with its European-style arcades, cafes,

patisseries and halls, even before the arrival of cinema. Until the opening of the Atatürk Cultural Center on Taksim Square in the 1970s, the cinemas in the district hosted all sorts of cultural events, including concerts, ballet performance and visiting shows.

Most non-Muslim Ottoman citizens and Levantines left not only the area but also Turkey by the mid-twentieth century. Still, Beyoğlu is marketed as the 'multicultural' or 'cosmopolitan' corner of the city in many contemporary representations produced by local and transnational culture makers. Real estate values in Beyoğlu witnessed a fate parallelling that of film business. After slummization in the 1970s and early 1980s, a conscientious effort was made by local businessmen, public personalities, and professionals to revive the district beginning with İstiklal Avenue. The ironic return of the (truncated and symbolic) tramway, to a now pedestrianized İstiklal Avenue in 1991 marked the official start date of the process in which Beyoğlu was re-created as a landscape of nostalgia. Beyoğlu Municipality and Istanbul Foundation for Culture and Art (IKSV), which organizes the Istanbul Film Festival, are the main actors who have worked, to reclaim the memory of the neighbourhood for the whole city.

Based in the district, cinema was a multi-cultural enterprise. Many professionals involved in the production, distribution and exhibition of films were of Armenian, Jewish and Greek origins. If actors, they would use pseudonyms on the screen – for example, Kenan Pars who passed away in March 2008, after having played a role in nearly three hundred films, was an Armenian Turk with the given name Krikor Cezveciyan. The memory of cinema and non-Muslim minorities are intimately connected even though the films may not take on the issue

90 *World Film Locations* / Istanbul

moralistically with themes of national identity and modernization, and the relationships between couples from different social and economic classes, only to affirm traditional gender roles and social values. Typically, films tended to straddle a fine line between selling images of Istanbul and participating in a civilizing process, simultaneously training their characters in urban behaviour and showing how they are able to resist to the temptations of the city.

Yeşilçam and its audience practices may be defunct but by no means dead. The 1990s witnessed the return of Yeşilçam films and a matching proliferation of Yeşilçam-inspired TV dramas on private channels, Yeşilçam-inspired block-busters in cinemas, as well as the emergence of revalorizing studies on Yeşilçam films growing out of communication faculties at private universities that have been opened in ever-increasing numbers since the 1990s. Part of the appeal of old films is that they show 'the streets, the old gardens, the Bosphorus views, and the broken-down mansions and apartments in black and white' (Orhan Pamuk 2005: 32–3) and thereby act as memory objects and provoke nostalgia.

In the 1990s, the backstreets of Beyoğlu became the preferred setting of films on marginal lives outside mainstream society, featuring figures such as prostitutes, transvestites, drug addicts and even a dwarf (*Dönersen Islık Çal/Whistle If You Come Back* [1992], *The Night, Gece, Melek ve Bizim Çocuklar/The Angel, and Our Boys* [1993], *Aşk Ölümden Soğuktur/Love is Colder than Death* [1994], *Ağır Roman/Heavy Novel* [1997], *Anlat Istanbul/Istanbul Tales* [2005]). In the 2000s, however, in Turkish-German director Fatih Akın's much celebrated films (*Crossing the Bridge: The Sound of Istanbul* [2005], *Head-on* [2004], and *The Edge of Heaven* [2007]), principle characters all travel from Germany to Istanbul to find a home base at Beyoğlu's Grand Hotel de Londres overlooking the Golden Horn and the historic peninsula. Coinciding with the international success of New Turkish Cinema at the festival circuit, thanks partly to European funding schemes such as Eurimages, this is a decidedly transnational Beyoğlu where once again multiple languages are spoken. ✤

of minorities in an explicit way. One of the interesting accounts of Beyoğlu and cinema is the memoir of Italian Levantine Giovanni Scognamillo (1929–) whose father was the manager of the famous movie theatre Elhamra. Scognamillo began his career writing film criticism for the press, worked in motion picture advertising, and wrote much quoted histories of Turkish cinema. His memoir takes us on a journey along a vibrant İstiklal Avenue. Today, İstiklal Avenue is once again the cultural heart of the city with thousands of people leisurely strolling at any time of the day.

Only second to İstiklal Avenue, and off of it, is Yeşilçam Street on our cinematic map. It was on and around Yeşilçam Street that artists' agencies, advertising, production, and distribution companies gathered along with famous movie theatres, such as Emek, İpek and Rüya. 'Yeşilçam' came to refer to a time when hundreds of films were hurriedly produced every year, and to the cumulative culture of local film production and consumption. Yeşilçam films consisted predominantly of melodramas and comedies; and its audience of families. They dealt

Beyoğlu is marketed as the 'multicultural' or 'cosmopolitan' corner of the city in many contemporary representations produced by local and transnational culture makers.

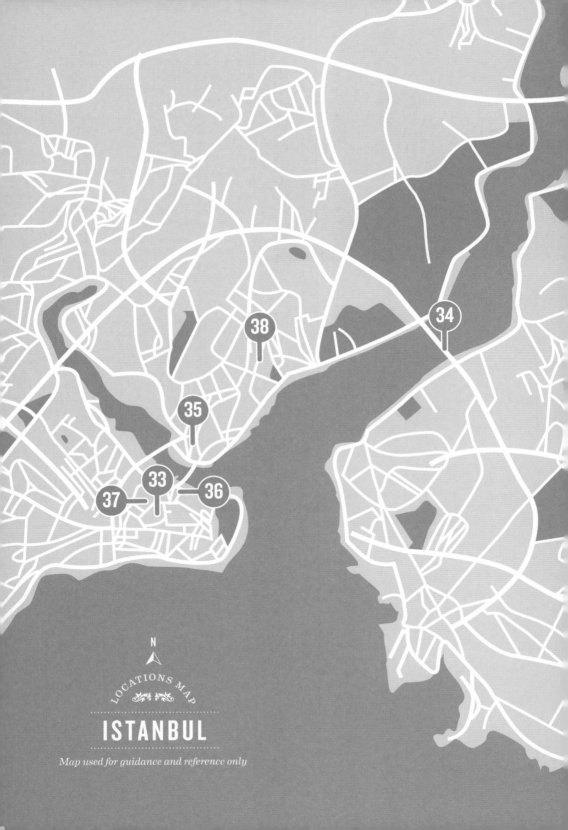

LOCATIONS MAP

ISTANBUL

Map used for guidance and reference only

ISTANBUL LOCATIONS

SCENES 33-38

THE STORM/BAHOZ (2008)

Istanbul University, Beyazıt Square

KURDISH DIRECTOR Kazim Öz's second feature *The Storm* largely takes place in Istanbul. Cemal, a young Kurdish man, arrives in Istanbul from his remote village in Dersim province for his university education. In this particular scene, we see Cemal with his luggage in his hand in front of the iconic gate of Istanbul University. Here at the Istanbul University Cemal start his experiences that will allow him to realize his own identity, as he becomes involved with a Kurdish political youth group. Although there are now 44 universities and higher education institutions in Istanbul, including eight state universities, most film-makers tend to use this particular location when there is a scene with university students involved. This is largely due to the beautiful architecture of the gate. However, this location is not only a primary location for films but also for the news covering student protests in Istanbul. Historically the students of Istanbul University are known for being the frontline protestors for the social, political and educational matters in the country. Over the last few decades violent crackdown by the police, who used excessive force against the student protestors, continued to occupy the headlines of national media, hence producing this easily recognizable, iconic image. ➦*Mustafa Gündoğdu*

(Photo ©Zehra Derya Koç)

Directed by Kazım Öz
Scene description: Cemal arrives at Istanbul University
Timecode for scene: 0:07:10 – 0:07:20

 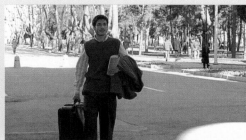

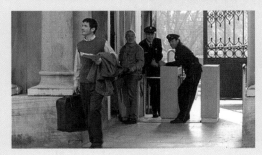

Images ©2008 Mezopotamya Sinema; Yapim I3 Film

MEN ON THE BRIDGE/KÖPRÜDEKILER (2009)

The Bosphorus Bridge

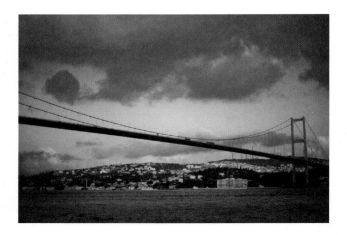

ASLI ÖZGE'S documentary-like *Men on the Bridge* tells three parallel stories of three men who make their living on the Bosphorus Bridge: a dolmus (shared taxi) driver, a traffic police officer, and a teenager who sells roses to cars that are stuck in traffic - and what traffic it is! The bridge (one of the two over the Bosphorus) was contructed in 1973 and has since become one of the symbols of the city. However, the film shows the bridge not in the postcard fashion other films often do (although there is also that, when the police officer takes a girl out on a date), but up close, flooded by cars, overrun by headlights that barely move during rush hour. This is not the exotic and metaphorical bridge that connects Europe and Asia, the East and the West, but the massive steel and concrete construct millions of Istanbullus experience every day, when they make their daily commute between the continents. The bridge has a strong presence in people's lives, thus also in the film, whether shot from below like a leviathan, or seen from afar as it usually is when the rose seller Fikret is hard at work. The drama as well as the visual language in the film is rather subdued, very close to 'real' life – daily struggles of ordinary citizens are revealed by non-professional actors, through a hand-held camera and without any musical score. The biggest surprise of the film is that there is none: amidst all the crossings on the bridge, the three main characters' paths never really cross. **↝Melis Behlil**

(Photo ©Zehra Derya Koç)

Directed by Aslı Özge
Scene description: Fikret sells roses on the connecting highway to the bridge
Timecode for scene: 0:05:54 – 0:07:24

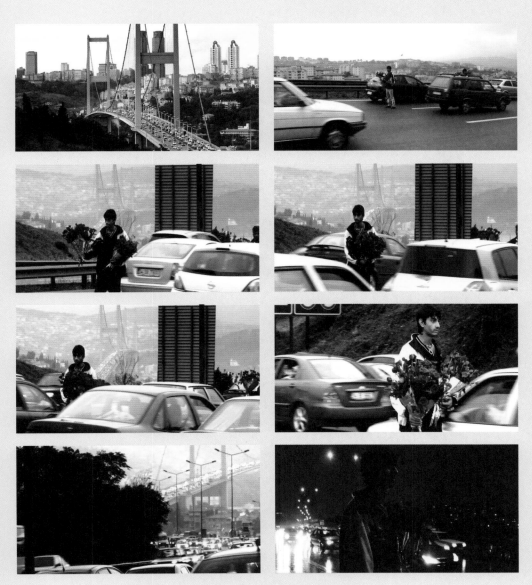

Images ©2009 Endorphine Production; Yeni Sinemacilar; Kaliber Film

WRONG ROSARY/UZAK IHTIMAL (2009)

Saint Pierre Church, Galata, Istanbul.

GALATA, once a neighbourhood where predominantly non-Muslim communities lived, is located at the north of the Golden Horn, and is one of the oldest and most beautiful districts in Istanbul. Mahmut Fazıl Coşkun's exceptional debut *Wrong Rosary* portrays a Galata of old apartments, centenarian buildings, ancient monuments, windy streets, antiquarian bookstores, historical mosques and churches. The narrative revolves around an impossible love between Musa (Nadir Sarıbacak), a young muezzin who is assigned to Tophane Karabaş Mosque in Galata, and his neighbour Clara (Görkem Yeltan), who is a Catholic nurse. One day, Musa pulls a rosary from his pocket during afternoon prayer in the mosque, but the man sitting next to him notices the cross attached to Musa's strange prayer-beads instead of an imame (a long piece marking the beginning of the string in Muslim's prayer-beads). This, in fact, is a cross necklace, which Clara dropped. When Musa perceives the man's bewildered gaze, he embarrassedly puts the rosary back into his pocket. This peculiar scene is followed by a scene where Musa visits the church Clara attends regularly, Saint Pierre Catholic Church, to return the rosary. As the shy lover enters this tremendous mediaeval Latin church, which was built in 1604 by the Genoese and rebuilt by the Fossati brothers from 1841 to 1843, he takes a seat where he comes across Mr Yakup the bibliopole (Ersan Uysal). As the two are softly talking about an old book, Clara approaches with a hand-basket to collect some charity amount for the church. Musa gently puts her cross necklace inside the basket, staring at Clara's angelic face, which is a moment that will prove to be life changing for all three of them. ➼*Cihat Arınç*

(Photo ©Zehra Derya Koç)

Directed by Mahmut Fazıl Coşkun
Scene description: Musa visiting the Saint Pierre Church to see Clara
Timecode for scene: 0:23:30 – 0:26:21

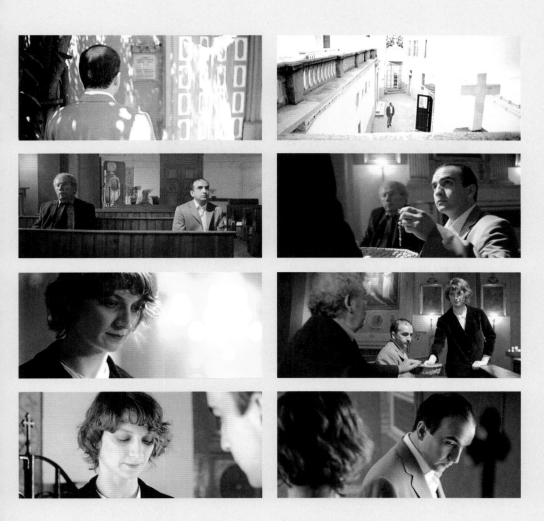

10 TO 11/11'E 10 KALA (2009)

Tahtakale, Eminönü

10 TO 11 is the story of a collector, Mithat Esmer (the director's real life uncle, about whom she previously made a documentary as well) and Ali (Nejat İşler), the concierge of the building he lives in. Before we are introduced to the interiors of Mithat's apartment, stuffed with all kinds of items (newspapers, photographs, liquor bottles, watches, torches, luggage, lottery tickets and more), we hear the distinctive sounds of Istanbul, as the opening credits roll and as Mithat strolls around the Eminönü-Karaköy region. One of the busiest districts of Istanbul, the region can easily be identified even only with its sound: the seagulls, the whistle of the ferries and the maddening sound of the crowd on the embroiled street market. The sounds continue as the camera enters and strolls around Mithat's apartment. With the help of this sound-bridge, we realize that this chock-a-block apartment is a sort of 'canned Istanbul' where time and space accumulate. Mithat, challenged by the residents of the building who want to demolish the building to build a new one, resists. He stays in, assigning Ali to continue buying items for his collection. From then on, Ali starts interacting with the city. It seems as if the city and 'life' have been handed down from Mithat to Ali. Through Mithat's items Ali starts establishing himself a new life. Therefore, it is not a coincidence that Ali finds the eleventh volume of the 'Istanbul Encyclopedia' for which Mithat has been searching for a long time. Selling all other volumes to a secondhand shop secretly and leaving only this rarely found volume to Mithat, Ali disappears and blends into the city, which he only discovered recently. ➡️***Senem Aytaç***

(Photo ©Zehra Derya Koç)

Directed by Pelin Esmer
Filming location: Mithat walks around Eminönü
Timecode for scene: 0:00:11 – 0:06:27

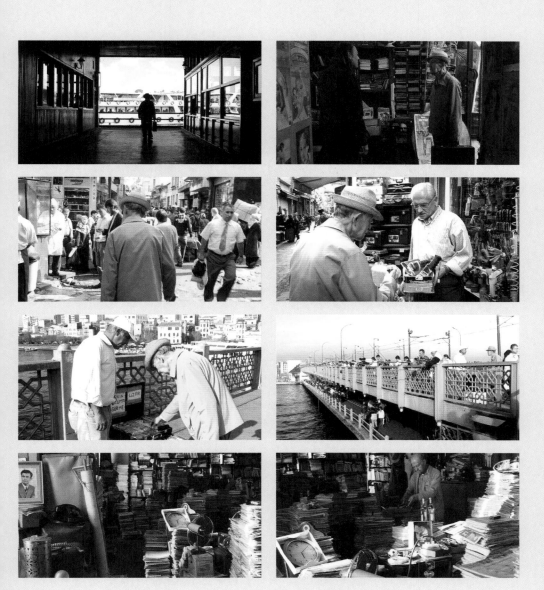

THE INTERNATIONAL (2009)

Süleymaniye Mosque

TRUE TO ITS NAME, Tom Tykwer's *The International*, takes place in various different locations from New York to Berlin before concluding in Istanbul. Tykwer introduces Istanbul quite spectacularly, with an aerial view of Galata Bridge shot on 65 mm film to enhance the sharpness of the image. We are then taken to the Süleymaniye Mosque, where the executive of the bank IBBC (International Bank of Business and Credit) meet a Turkish businessman (Haluk Bilginer) to shake on a deal that will provide arms for both Israel and Iran. Lois Salinger (Clive Owen) from Interpol is following them in the hope of recording their conversation, which will help him prove an international scam. However, as they enter an underground location to continue their conversation, the Basilica Cistern, he looses reception to the microphone, which was placed on Skarssen's coat, and fails to record the information he wished to record. The scene takes place in the courtyard of the Süleymaniye Mosque, one of the landmarks of Istanbul's silhouette, which was commissioned by Sultan Süleyman to the architect Sinan in the sixteenth century. Tykwer, in the DVD commentary of the film, talks about his fascination with Istanbul and that he wanted to use all his favourite locations in the film. The result is a geographically creative scene where the Basilica Cistern moves beneath the Süleymaniye Mosque, as the characters enter into the cistern through a door that is supposedly located in the courtyard of the mosque. The cistern, built in the sixth century, is in reality a mile away from the mosque and could not be accessed through the mosque's courtyard. **Özlem Köksal**

(Photos ©Özlem Köksal)

Directed by Tom Tykwer
Scene description: IBBC executive Skarssen meets Ahmet Sunay in Istanbul
Timecode for scene: 1:36:48 – 1:42:18

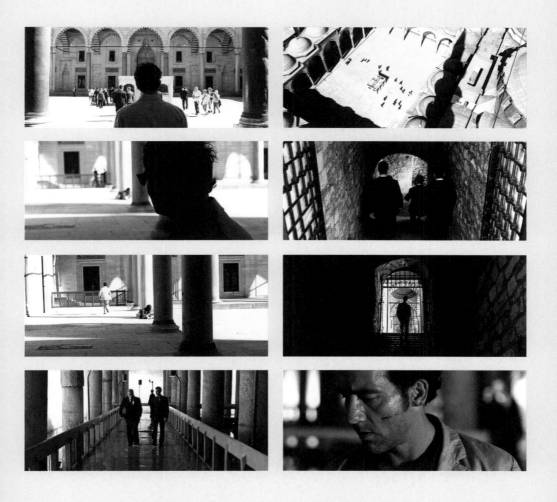

PAINS OF AUTUMN/GÜZ SANCISI (2009)

LOCATION *Taşkışla*

TAŞKIŞLA, as one of the architectural signifiers of the city, serves as a meeting place for two childhood friends, Behçet (Murat Yıldırım) and Suat (Okan Yalabık) in the early scenes of *Pains of Autumn*. In the bleak political atmosphere of 1955 Turkey, the vast courtyard of Taşkışla symbolizes the intersection point of deepening contradictory ideologies where nationalist demonstrations take place to protest against the violent acts in Cyprus. The emotions are high with slogans filled with pledges of spilling blood in the name of 'making Cyprus a Turkish island'. Working as a research assistant at the Law School, Behçet, a right-wing nationalist, seems to have an opposite worldview to that of Suat's, who is an investigative journalist. In the courtyard of Taşkışla, people chant 'Cyprus belongs to Turkey' and Behçet is seen in the crowd clapping and chanting slogans with many others while Suat is carelessly taking pictures. In this sequence, Behçet, uneasy with Suat's sarcastic behavior, drags him into the hallway of this impressive building. The scene gives the first hint of the boiling tension and the government's provocation of the masses which will end up in a climactic mayhem against the Greek Orthodox (Rum) minorities in Istanbul called '6–7 September Events'. Taşkışla is also known to have survived the clash of the rebellious troops in 1909 ('March 31 Incident'). The building was constructed as a masonry between 1848–1853, and later turned into a military medical academy for the Ottoman Army under the rule of Sultan Abdülmecid. Today it serves as an exquisite setting for movies and is home to the School of Architecture of Istanbul Technical University. ⤳*Aslı Tunç*

(Photo ©Umut Türem)

Directed by *Tomris Giritlioğlu*
Scene description: Behçet and Suat meet in the courtyard of Taşkışla
Timecode for scene: 0:06:48 – 0:08:03

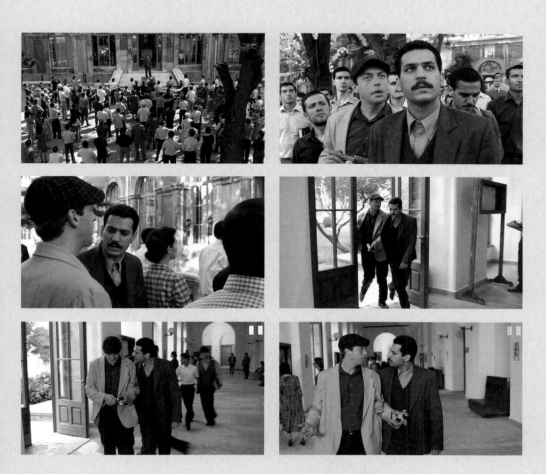

NURI BILGE CEYLAN

Text by
ASUMAN
SUNER

A Distant Image of Istanbul

NURI BILGE CEYLAN'S *Uzak/Distant* (2002), the winner of the both the Grand Jury Prize and acting awards for its two male lead characters (Muzaffer Özdemir and Mehmet Emin Toprak) at the 2008 Cannes Film Festival, is set in Istanbul. As a matter of fact, Ceylan's films are not so much about the big city, but the small town. Boredom of provincial life is a recurrent theme in Ceylan's cinema. The province appears not a particular locality in these films, but a mode of feeling. This thematic preoccupation prevails also in *Distant* despite the centrality of the urban space of Istanbul to the story.

The story of *Distant* depicts the morbid relationship between a commercial photographer, Mahmut (Muzaffer Özdemir), and his young cousin, Yusuf (Mehmet Emin Toprak), from his native provincial town, who has come to Istanbul to start a new life. Yusuf hopes to find a job on a cargo ship, which, he thinks, would provide him with an adventurer's lifestyle. Soon, however, he realizes that life in Istanbul is not as promising

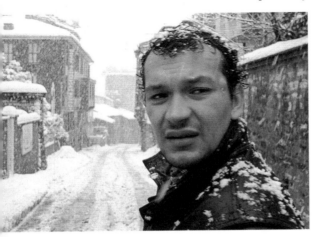

as he thinks. As his stay in Mahmut's apartment drags on, Mahmut makes him feel like an unwanted guest. Gradually, Yusuf is made to feel unwelcome not only by his host, but also by the city. Once a symbol of freedom and mobility, Istanbul gradually turns into a constraining space, not much different from the small town from which Yusuf escaped. Beneath its charm, the city is aloof and uninviting. As Yusuf's awkward attempts to communicate with others fail, he feels increasingly lonely and isolated.

Yusuf's relationship to Istanbul is based on seeing and watching from afar. He looks at the city from a spiritual distance in the sense that he cannot penetrate its surface, no matter how hard he tries. *Distant* does not show typical urban images with busy districts and crowded streets but quite peculiar renderings of the city, emphasizing solitariness and void. Despite the predominance of lovely scenery, a sense of stasis and immobility is intrinsic to cityscape shots, which at times produces an uncanny sensation. Projecting Yusuf's mental state onto the space, everything in the city appears to be abandoned and frozen in time. Caught in the rare white of a snow storm, Istanbul appears barren and deserted. In one scene, for example, as Yusuf walks by the docks, the camera follows him through the snow and comes upon a ship that is rusted, half-sunken and tilted to one side. The ship stands there, in the words of Anthony Lane, like 'some relic of a forgotten civilization or a frozen mammoth' (*The New Yorker*, 15 March 2004). Eliding the boundaries between the real and the unreal, the image produces a disturbing sense of ambiguity.

The theme of provinciality is articulated in Distant not only in relation to Yusuf, but also to Mahmut, a character who supposedly

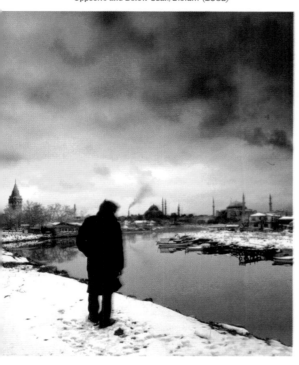

is more intellectual and bourgeois. At first sight, the story of the film is about the slowly deteriorating relationship between a guest and a host, as they both discover the many small elements dividing them day by day. A deeper look, however, proves that the morbid relationship between Yusuf and Mahmut arises not so much from the elements dividing them, but from what they share. What Mahmut sees in Yusuf is not simply a stranger with vulgar manners invading his private space, but someone who reminds him of something all too familiar and intimate. Yusuf's provincial identity brings Mahmut face to face with his own provincial background, the suppressed side of his own identity. It is not

Yusuf's relationship to Istanbul is based on seeing and watching from afar. He looks at the city from a spiritual distance in the sense that he cannot penetrate its surface, no matter how hard he tries.

Yusuf's alien presence that he cannot stand, but the affinity between the two.

Distant, like Ceylan's previous films, drew upon elements from his own life. In an interview with Fırat Yücel, Ceylan indicates that it is easier for him to create a convincing fictional world by adopting the perspective of his middle-class, educated, and intellectual male characters who function like a 'catalyzing' element between himself and the story (*Altyazı*, 2008, vol. 77, pp. 22–30). These catalyzing characters share a lot of similarities with Ceylan himself. Mahmut in *Distant* is a character who was created by borrowing several elements from Ceylan's own life. He is a commercial photographer just like Ceylan himself once had been. His parents in the film are played by Ceylan's real-life parents. Most interestingly, *Distant* is set in Ceylan's own apartment in Cihangir, a stylish district close to the famous Taksim square and Beyoglu area, the heart of Istanbul's cultural life. Ceylan describes Mahmut's apartment in the film as his prison (interview with Howard Feinstein, *Indiwire*, 9, March 2004).

Distant is set at the intersection of two overlapping journeys. While the direction of Yusuf's journey from the province to Istanbul is the core narrative, there is another journey in the film, away from Istanbul. During Yusuf's stay in Mahmut's apartment, Mahmut's ex-wife is about to migrate to Canada with her new partner. Mahmut feels increasingly disoriented by both his ex-wife's approaching departure and Yusuf's unwelcome arrival. Both journeys take place against his will and make him feel more and more alienated from the life that he has established for himself in Istanbul. By the end of the film, he appears to be stuck in his own self-made imprisonment. On the morning when his ex-wife leaves for Canada, Mahmut finds out that Yusuf has also left. This double abandonment marks the ending of the film. In the final scene, we see Mahmut on the shore of the Bosporus smoking the cheap local cigarettes that he once refused to smoke when Yusuf offered them to him. Ceylan considers this as a sign of hope, in the sense that the character is perhaps ready to change and that he has the potential to do so (interview with Jason Wood, *Kamera*, May 2004). ✤

GO FURTHER

Recommended reading, useful websites and further viewing

BOOKS (ENGLISH)

New Turkish Cinema
By Asuman Suner
(I. B. Tauris, 2010)

Istanbul:
Between the Global and the Local
Edited by Çağlar Keyder
(Rowman and Littlefield, 1995)

Orienting Istanbul:
Cultural Capital of Europe
Edited by L. Soysal, I. Türeli and D. Göktürk
(Routledge, 2010)

Istanbul:
Memories of a City
By Orhan Pamuk, trans. Maureen Freely
(Faber and Faber, 2005)

Cinema in Turkey
A New Critical History
By Savaş Arslan
(Oxford University Press, 2010)

The Remaking of Istanbul:
Portrait of an Ottoman City in the
Nineteenth Century
By Zeynep Çelik
(University of California Press, 1993)

BOOKS (TURKISH)

Türk Sinemasında Istanbul
By Agah Özgüç
(Horizon 2011)

Vesikalı Şehir
By Feride Çiçekoğlu,
(Metis, 2006)

Bir Levantenin Beyoğlu Anıları
By Giovanni Scognamillo
(Metis, 1990)

Cadde-i Kebir'de Sinema
By Giovanni Scognamillo
(Metis, 1991)

Istanbul Ansiklopedisi
By Reşat Ekrem Koçu
(Istanbul Ansiklopedisi ve Neşriyat Kollektif
Şirketi, 1961)

WEBSITES

www.iksv.org
www.nbcfilm.com

CONTRIBUTORS

Editor and contributing writer biographies

EDITOR

ÖZLEM KÖKSAL received her PhD degree from University of London, Birkbeck College (2011) with a dissertation examining the relation between collective memory, history and cinema in Turkey. She has published various articles and reviews both in English and Turkish and currently teaches at Bilgi University, Istanbul.

CONTRIBUTORS

CİHAT ARINÇ is a writer and academic researcher based in London. He is currently a Ph.D. candidate in the Department of Visual Cultures at Goldsmiths College, University of London. He has studied film at Istanbul University and received a Master's degree in philosophy of film at the University of Bosphorus, Istanbul. He conceives the spectral medium of cinema as a time-based technology of memory, revealing self-reflexive processes in documentation. His research interests cover the following topics, focusing on the mnemopolitics of film around the themes of displacement, narration and haunting: contemporary film theory, documentary, biopic, video oral history, experimental video essay, auto-ethnographic film, historical narrative cinema, and contemporary film cultures in Turkey.

UMUT TÜMAY ARSLAN completed her Ph.D. in 2007 at the Department of Radio Television Cinema, Ankara University. Her articles and essays have appeared in various journals and magazines including *Toplum ve Bilim, Kültür ve İletişim, İletişim Araştırmaları, Mürekkep, Kaos GL* and *Alt Yazı.* Her first book, *Bu Kabuslar Neden Cemil?/Why These Nightmares Cemil?* (Metis, 2005), is an analysis of masculinity and modernity in Turkish Cinema in the 1970s. She also contributed to *Çok Tuhaf Çok Tanıdık/Strangely Familiar, Familiar Estranged* (Metis, 2005), a collective work analyzing the now cult film *Vesikalı Yarim/My Licensed Beloved* (Ömer Lütfi Akad, 1968) through Turkish modernity. Her last book, *Mazi Kabrinin Hortlakları/ Spectres of Grave Called Past* (Metis, 2010), is investigating, via Turkish cinema, how social power, through permeating emotions and beliefs, discloses itself. She is currently Assistant Professor in the Department of Radio Television Cinema at Ankara University.

EYLEM ATAKAV is a lecturer in Film and Television Studies at the University of East Anglia. She is the author of *Women and Turkish Cinema: Gender Politics, Cultural Identity and Representation* (Routledge, 2012) and the

editor of *Directory of World Cinema: Turkey* (Bristol: Intellect Books, 2012). She is currently working on two co-edited collections: *Women and Contemporary World Cinema* and *From Smut to Soft Core: 1970s and World Cinema.*

SENEM AYTAÇ After graduating in Psychology from the Middle East Technical University in Ankara, Senem studied Film and Television at Istanbul Bilgi University, receiving her Master's degree with a thesis entitled 'The Present As Nightmare: Dystopian Sentiment In Contemporary American Film'. She has worked as a teaching assistant at the same department between 2001–2005 and continued to lecture Film History in Bosphorus University. She has been on the editorial board of *Altyazı* Monthly Cinema Magazine since 2004 and one of the editors of the magazine since 2006. Aytaç, who is also a member of the board of SİYAD, still organizes and teaches film seminars at various institutions and writes on film.

CANAN BALAN is Assistant Professor in the Film and Television department at Istanbul Şehir University. She received her Ph.D. degree from the University of St Andrews with a dissertation on the early cinema spectatorship in Istanbul. She has published articles on early cinema, shadow-play and the cinematic representations of Istanbul.

MELİS BEHLİL is Assistant Professor of Cinema Studies at Kadir Has University in Istanbul, Turkey. She received her Ph.D. from the Amsterdam School for Cultural Analysis (ASCA) at the University of Amsterdam in 2007. Her areas of research interest are film industries, production studies, and contemporary Turkish cinema. In addition to teaching and other academic duties, she writes film reviews for various publications and co-hosts a weekly radio show.

FERİDE ÇİÇEKOĞLU has a background in architecture, literature and film. After receiving her Ph.D. in Architecture at the University of Pennsylvania, she started a career in teaching in Turkey. However, she was imprisoned during the military junta of 1980 because of her political opposition and this became a turning point for her, since she took an interest in literature and writing letters in prison as a way of survival. Her first book was a novella, in the form of letters from a child in prison. Later, she adapted this novella for screen, with the title *Don't Let Them Shoot the Kite* (Tunç Başaran, 1989) which ➡

CONTRIBUTORS

Editor and contributing writer biographies (continued)

led to a career in screenwriting that includes films like *Journey to Hope* (1991, Academy Award for Best Foreign Film). She is the author of *Vesikalı Şehir/Licensed City* (Metis, 2006) and continues to write for both film and television. Currently she is the director of undergraduate and graduate programs in Film and Television at İstanbul Bilgi University.

ÖVGÜ GÖKÇE is a film critic and a member of the editorial board at *Altyazı*, the prominent independent monthly film magazine in Turkey. She has contributed to many publications as writer and editor, and has been working on Turkish cinema and international cinemas for several years. After studying philosophy at Boğaziçi University, Istanbul, Övgü Gökçe received her Master's degree from Istanbul Bilgi University, Department of Film and Television, with a thesis on narration in post-revolutionary Iranian cinema. She continued her studies at Ohio University School of Interdisciplinary Arts, where she is a Ph.D. candidate writing her dissertation on historiography of sentiments in contemporary Turkish film. Her areas of interest are Turkish cinema, transnational cinemas, melodrama, and self-reflexivity with an interdisciplinary approach, particularly drawing from visual arts and aesthetics. She is currently working as the project coordinator at Diyarbakır Arts Center, Turkey.

ÖZLEM GÜÇLÜ is a Ph.D. candidate in Media and Film Studies at the School of Oriental and African Studies, with a thesis entitled 'Silent Female Characters in the New Cinema of Turkey: Gender, Nation and Memory'. She works and writes on Turkish cinema – particularly on the new cinema of Turkey – in relation to the issues of gender, sexuality, nation and ethnicity. Currently, she is Research Associate at the Sociology Department of Mimar Sinan University.

MUSTAFA GÜNDOĞDU is a founding member and current coordinator of the 'London Kurdish Film Festival' and in the past had advised the Glasgow 'International Human Rights Documentary Film Festival'. He is also advisor and a founding member of the 'New York Kurdish Film Festival', launched in 2009. In addition to organizing several other Kurdish film festivals in Europe, including Ireland and Norway, he has published several articles on Kurdish cinema in various academic journals and books. He lives in London where he works for the London-based Kurdish Human Rights Project (KHRP).

AHMET GÜRATA teaches film history and theory in the Department of Communication and Design, Bilkent University. He holds a Ph.D. from the London Consortium, which examined remakes and cross-cultural reception in Turkish cinema. He has published articles on Turkish cinema and film consumption. His research focuses on film history, reception and world cinema. He is the editor of *sinecine* film studies journal and contributes to a number of publications.

ZEHRA DERYA KOÇ After graduating from Boğaziçi University with a degree in history, Koç decided to continue her studies at Galatasaray University, this time choosing media studies and communications as her discipline. She has made two short films named 'Ashes' (Scriptwriter and Director: Zehra Derya Koç, 19', Turkey, 2010, 35 mm, Colour) and 'Attempts to Escape from Mothers' Worlds' (Scriptwriter and Director: Zehra Derya Koç, 12', Turkey, 2011, HDV, Colour).

ÖZGE ÖZYILMAZ is expecting to complete her Ph.D. degree in December 2011 at İstanbul University and works as a teaching assistant at İstanbul Bilgi University. For her Ph.D. research, she also studied at the University of East Anglia as a visiting scholar on cinema culture in the early Republican period of Turkey and its relation to westernization and modernization. Her main research interests are modernization and cinema, reception of American movies in Turkey, and Hollywood stars and their reception in Turkey. She has published articles in national cinema magazines including *Seyir, Yeni İnsan Yeni Sinema* and *Altyazı*.

YEŞİM BURUL SEVEN is a lecturer in Film and Television at İstanbul Bilgi University, where she teaches courses on Turkish cinema, film history and popular culture. She is the producer and presenter of *Sinefil*, a weekly radio show on film and everything related to film, at Açık Radyo (Open Radio), Istanbul. She is also a regular contributor to *Altyazı* Monthly Film Magazine, and has contributed to daily newspapers and other publications as an independent film critic. She is a member of Turkish Film Critics Association (SIYAD).

LEVENT SOYSAL completed his Ph.D. at the Department of Anthropology, Harvard University (November 1999). Between 1998 and 2001, he was Assistant Professor of Anthropology at the John W.

Draper Interdisciplinary Master's Program in Humanities and Social Thought, New York University, where he taught graduate courses in the area of *The City*, focusing on contemporary urban spaces and cultures, and the transnational movements of peoples, cultures and goods. His research interests include: city, globalization and the metropolis, and transnationalism. His current research, titled World City Berlin and the Spectacles of Identity: Public Events, Immigrants, and the Politics of Performance, concerns the changing meaning and constitution of public events and the performance of identity. He has published in a variety of academic journals and recently co-edited *Orienting Istanbul: Cultural Capital of Europe?* (Routledge, 2010).

ASUMAN SUNER is Associate Professor in the Department of Humanities and Social Sciences at Istanbul Technical University. In addition to several articles published in edited books and academic journals, she has a recent book, entitled *Turkish Cinema: Belonging, Identity and Memory* (I. B. Tauris Press, 2009). Turkish and Arabic editions of this book were previously published respectively by Metis Press (2006) in Istanbul and Dar Kreidieh Press (2008) in Beirut.

ASLI TUNÇ Aslı Tunç is Associate Professor in the Media and Communication Systems Department at Istanbul Bilgi University. Her interest in movies started during her college years with a dream of becoming a film director. The closest she could get to her unfulfilled dream was getting a Masters degree in Film Studies and working as an assistant director in a documentary at Anadolu University in Eskişehir. After giving up to pursue a career in the movie sector, she went to the United States to get a Ph.D. in Mass Communications at Temple University. She has given various lectures and seminars at universities in the United States, the United Kingdom and Greece on freedom of expression. She has numerous publications on the issues of democracy, the media and the social and political impacts of new media technologies in Turkey and around the world. She occasionally writes film reviews since her love for cinema still haunts her.

İPEK TÜRELİ is Assistant Professor in the School of Architecture at McGill University. Her research and teaching focus is on visual culture, comparative urbanism and architectural history. She received her Ph.D. at the University of California Berkeley, and professional degrees at the Architectural Association and Istanbul Technical University, all in Architecture. Tureli has been the recipient of grants and fellowships by the UC Regents, Graham Foundation, MERC, Mellon Foundation Fellowship at Brown University, and AKPIA at MIT. She worked in architectural practice in Turkey and the United Kingdom, and taught at Middle East Technical University in Ankara, University of California Berkeley, and Brown University. She is the co-editor of *Orienting Istanbul: Cultural Capital of Europe?* (Routledge, 2010), a book that explores how processes of creative production and exhibition are intertwined with neoliberal urban restructuring, and the author of the forthcoming *Istanbul, Open City* (Ashgate).

FIRAT YÜCEL While studying Sociology at Boğaziçi University, Fırat Yücel edited the programme booklet of the Mithat Alam Film Centre. He then co-founded *Altyazı* Monthly Cinema Magazine in 2001, and started to work as the magazine's editor-in-chief. In addition to *Altyazı*, he published film reviews in several magazines and newspapers. After completing his masters in Cultural Studies at Bilgi University in 2006, Yücel served as a member of FIPRESCI jury at Istanbul, Rotterdam, Bratislava and Festroia (Setubal) film festivals. In 2009 he edited a book called *Reha Erdem: Aşk ve İsyan* which was published by Festival on Wheels in collaboration with Çitlembik Yayınları. A member of SİYAD (Cinema Writers' Association), Firat is currently studying his doctorate at the Radio-Television and Cinema Department of Istanbul University and continues to work as the editor-in-chief of *Altyazı*, which is now published by Boğaziçi University Mithat Alam Film Center.

FILMOGRAPHY

A comprehensive list of all films mentioned or featured in this book